MANGA
CRASH COURSE

Drawing Manga Characters and *Scenes From Start to Finish*

Mistiq arts

MINA "MISTIQARTS" PETROVIĆ

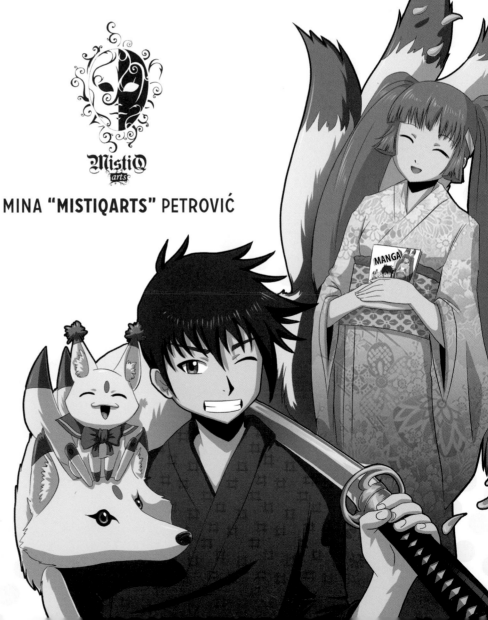

IMPACT

CINCINNATI, OHIO
IMPACT-BOOKS.COM

CONTENTS

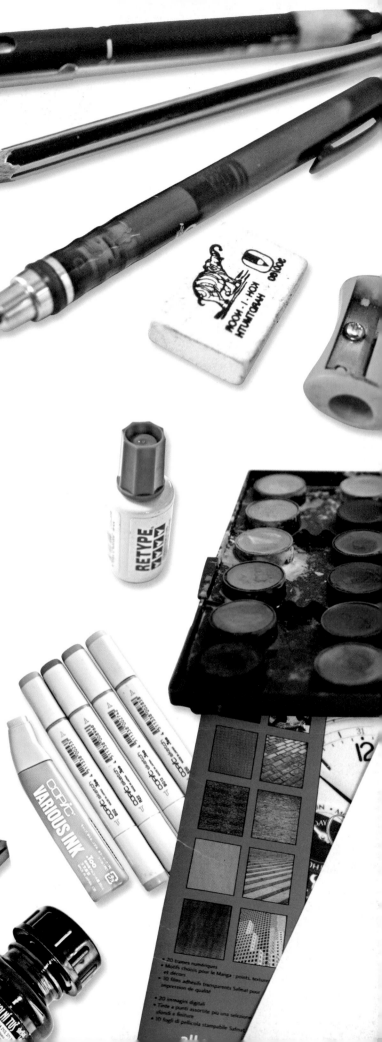

WHAT YOU'LL NEED

Basic Tools

0.1 Multiliner pen

clear eraser

pencil or technical pen

pencil sharpener

ruler

Additional Tools

black-and-white printer

colored markers

computer

paintbrush

permanent black ink

permanent marker

screentone

single-edged razor blade

watercolor paint

white ballpoint pen

white paint

WHAT ARE MANGA AND ANIME?

Manga lovers are drawn in by the strange designs, unusual art style, intriguing stories and interesting characters that characterize good manga.

As a manga lover, I wanted to create a simple book containing basic techniques for aspiring manga artists.

In this book you will learn how to draw manga scenes and characters the fastest way possible, even if you have never drawn before. You will learn the key elements to making manga characters and scenes and how to master this art style.

But before we start drawing, it is important to know the basics about the different kinds of manga and anime.

Manga is the Japanese term used for printed comic books from Japan. Manga-styled comic books from other countries have different names. For example, a manga from Korea is called *manhwa* and a manga from China is called *manhua*. The manga-inspired comic books from English speaking countries are called "original English-language manga" or "OEL manga."

Anime, short for "animation," is the term for all animated movies and series from Japan. Usually when a manga is famous enough in Japan, it is adapted into animated episodes.

Contrary to popular belief, manga is made for fans of all ages, not just for kids. Manga has different genres for people of different genders and ages.

Kodomo is a genre of manga and anime series for small children. Kodomo features cute mascots and stories about first friends, good manners and basic life lessons.

Shōjo manga and anime are series created for young and teenage girls, usually with stories full of magic, first crush experiences and friendship.

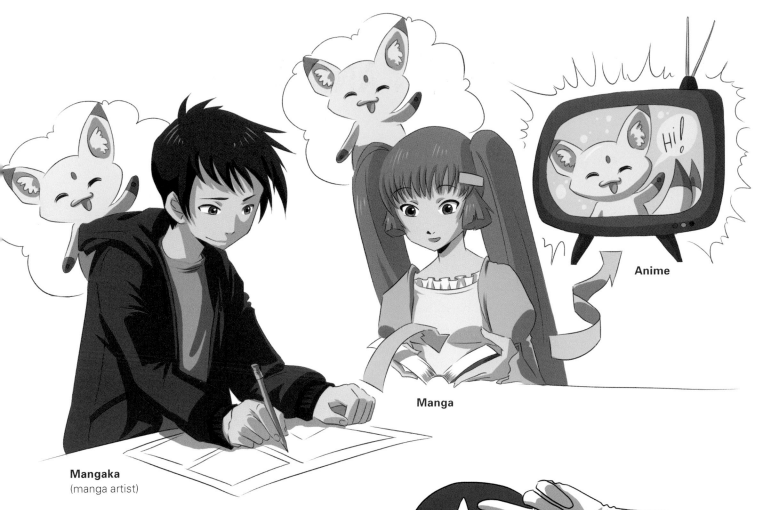

Mangaka
(manga artist)

Manga

Anime

Shōnen is the name for manga and anime series for young and teenage boys. The stories feature characters with super powers fighting to save humanity. Usually these feature a single hero with lots of helpers and friends. A lot of girls like to follow these series as well.

Seinen are manga and anime series for older teenage and mature males. Usually seinen manga features thriller-like storylines with many puzzles and mysteries.

Josei is the term for manga and anime series for older teenage and mature females. These stories are about daily life struggles and features interesting characters. They typically have complicated stories and plots.

Manga genres can also be sorted by popular themes:

Mecha is manga and anime featuring futuristic robots, in which the main characters are usually pilots.

Super Sentai is manga or anime featuring a group of super-powered crime fighters who use transforming robots as weapons.

MEET OUR MASCOTS!

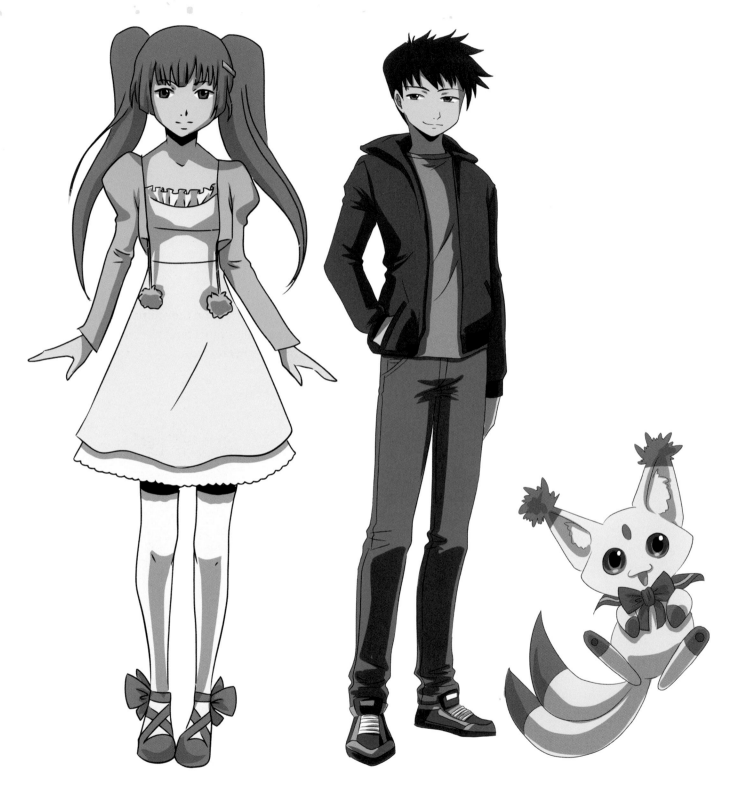

Maya is a high school student who is good at art and is teaching Marco about manga drawing. She is a guardian of the two-tailed fox.

Marco is a manga lover who is good at learning and writing stories. He is learning how to draw manga with you.

Mimi is a two-tailed fox, a mythical being from Japan. Each tail represents 100 years of age. Mimi shares all of her manga drawing tips in this book!

OSAMU TEZUKA

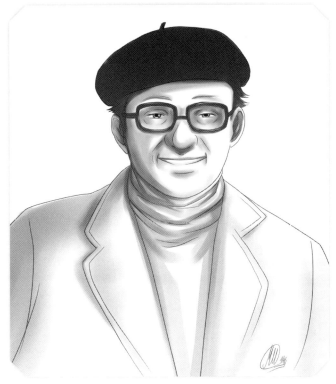

The Father of Manga

Osamu Tezuka (1928–1989), known as the "Father of Manga," was one of the first creators of modern manga in Japan. He produced more than 700 volumes of manga in his life, all with incredibly imaginative stories. A lot of his work was inspired by American comic books and the animated films of Walt Disney. His most famous works are *Astro Boy*, *Kimba the White Lion*, *Black Jack* and *Princess Knight*.

This is how our mascots might look if they were drawn by Osamu Tezuka.

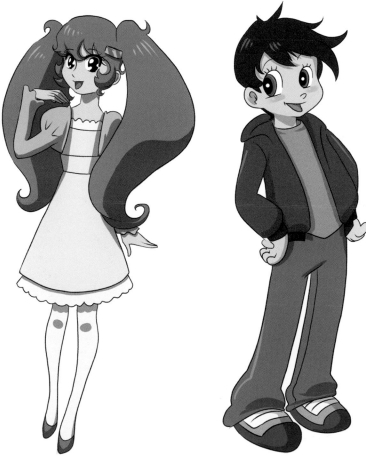

VISIT IMPACT-BOOKS.COM/MANGA-CRASH-COURSE FOR BONUS CONTENT.

7

GETTING
Ready

In this chapter we will cover the basic manga tools, as well as how to use them and make them last. Making manga takes just a few simple steps, so you will learn all you need to know about getting started. We will conquer your drawing fears together, plus learn how to ink your work and make your manga from scratch. Let's begin!

PAPERS AND PENS TO USE AND AVOID

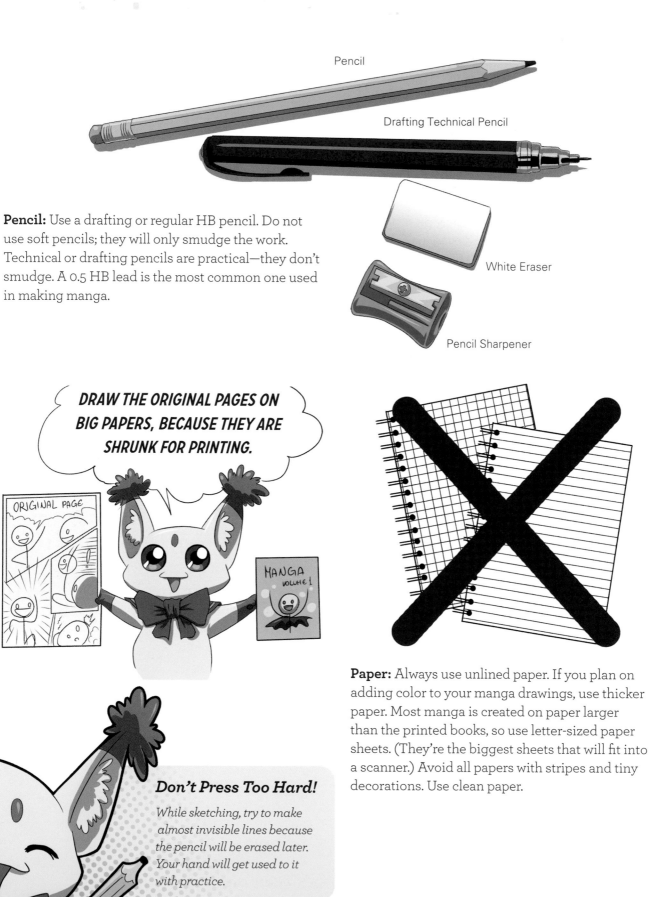

Pencil

Drafting Technical Pencil

White Eraser

Pencil Sharpener

Pencil: Use a drafting or regular HB pencil. Do not use soft pencils; they will only smudge the work. Technical or drafting pencils are practical—they don't smudge. A 0.5 HB lead is the most common one used in making manga.

DRAW THE ORIGINAL PAGES ON BIG PAPERS, BECAUSE THEY ARE SHRUNK FOR PRINTING.

ORIGINAL PAGE

MANGA VOLUME 1

Paper: Always use unlined paper. If you plan on adding color to your manga drawings, use thicker paper. Most manga is created on paper larger than the printed books, so use letter-sized paper sheets. (They're the biggest sheets that will fit into a scanner.) Avoid all papers with stripes and tiny decorations. Use clean paper.

Don't Press Too Hard!

While sketching, try to make almost invisible lines because the pencil will be erased later. Your hand will get used to it with practice.

INKING TOOLS: TIPS AND TRICKS

Inking is essential for manga pages. It strengthens the lines and fills in the black areas. Beginners can ink more easily with Multiliner pens of different thickness, but the 0.1 size usually works for most drawings. For bigger areas, it is useful to use a paintbrush and black ink, or a regular black permanent marker. Make sure to use a waterproof brand, so that you can use watercolors for coloring.

For more ambitious manga artists, there are a lot of special inks and ink nibs to use. The most common nib is the G-pen nib, which is used by professional manga artists. Nibs are changed every few manga pages, so it is wise to recycle the expensive equipment. If a G-pen is cut, it can be used for thicker lines.

A normal ink pen nib can be used for three different ink thicknesses, depending on how you tilt it while drawing. Experiment on scrap paper before trying it on your drawing.

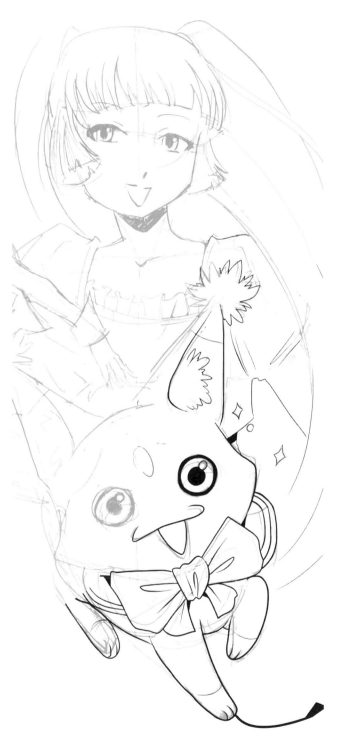

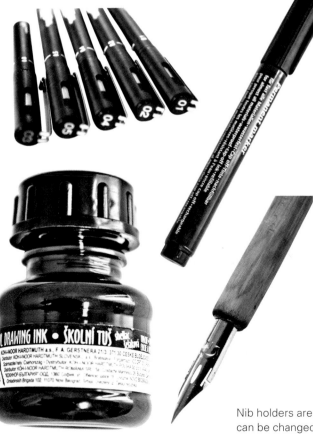

Nib holders are long lasting, and the nibs can be changed when they are used up.

VISIT **IMPACT-BOOKS.COM/MANGA-CRASH-COURSE** FOR BONUS CONTENT.

11

TOOLS FOR COLORING MANGA

Originally, manga pages were made in black and white, with some gray areas for shading. Color is used in some modern digital manga, but in Japan, manga is still made traditionally. Color is typically applied only for chapter covers, or official manga art. For coloring, there are several tools that you can use.

Watercolor paints are cheap and long lasting. With a good paintbrush you can color little details as well as the big surfaces.

Alcohol-based markers are commonly used in Japan. They are refillable and dry quickly. They are essentially watercolor paint in the form of a marker.

Some markers have different types of tips: chiseled, wide, pointy and soft brush. It is up to you to decide which brand to get based on the price and additional features.

FOR DAILY DEMONSTRATIONS AND INSPIRATION VISIT **IMPACT-BOOKS.COM**.

COMMON ART SUPPLIES TO USE

Manga drawings can also be made with very basic tools that we all have in our homes. When you start drawing manga you don't need any special equipment, only your school supplies and the will to learn.

Paper used in art class is a perfect starting tool for manga illustrations. Black ink, a paintbrush, a thin black marker, watercolor paint, a black permanent marker and a ruler are some of the tools almost every school student has. They are all you need to start drawing manga. Before you decide to go out and buy all the professional tools, you need to master all the basic techniques.

SCHOOL SUPPLIES ARE GREAT STARTING TOOLS!

Your regular pencil is just fine, as is a white eraser. Avoid multicolored or decorated erasers—they just make a mess by smudging the pencil lead.

20ml

WATER BASED - NON TOXIC VODNI BAZE - NETOXICKY

Art. No. 8550

FIGHTING FEAR: TIPS AND TRICKS

When starting out, lots of people are afraid even to touch their drawings, for fear they will mess them up. People expect to draw like their favorite artists right away, and when that is not the case, they might tear up their work, and get angry and scared that they are not good enough. To fight off these fears, follow these simple rules:

Rule 1: Remember that **everyone makes mistakes**, even famous artists. They all started with a single line on the page, just like you.

Rule 2: Practice makes perfect. The more hours you spend practicing and repeating the basic techniques, the better you will get.

Rule 3: Every mistake is fixable. You spilled some ink? You can cut out the damaged part and replace it with another piece of paper taped on the back of the page. After the page is scanned, no one will be able to see the attached paper.

You realized your character has a short arm or leg? Trace over your work and make new line art. Place a piece of fresh paper over your drawing and use the light coming through a window to trace over your work and fix the part you don't like. If you want, you can make or buy an animator's table.

Rule 4: Never trace someone else's work! While tracing your own work for fixing mistakes is allowed, tracing other people's work is considered stealing, and it doesn't improve your talent at all.

Rule 5: Keep your old work. It will be a reminder of how much you have improved.

USE WHITE PAINT AND A BRUSH TO COVER MISTAKES.

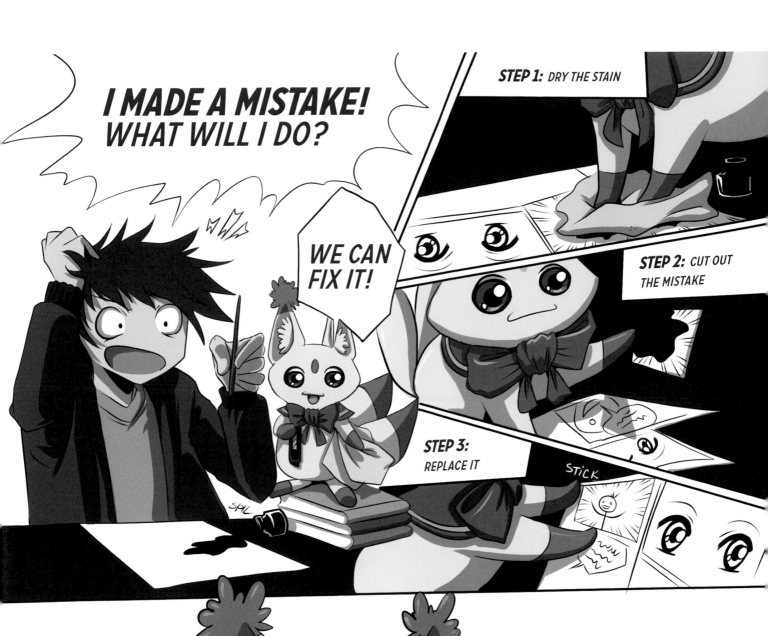

Use White Paint to Hide Mistakes

Using white paint helps the most because it can conceal most of the mistakes in manga. You can use white paint to cover up any ink mess by covering it with thin layers of paint, one after another.

VISIT **IMPACT-BOOKS.COM/MANGA-CRASH-COURSE** FOR BONUS CONTENT.

15

THE MANGA DRAWING PROCESS

Manga comic pages are made of many images that tell a story. They are carefully planned, and made step by step. You'll learn how to draw characters and scenes from start to finish in the next three chapters of this book.

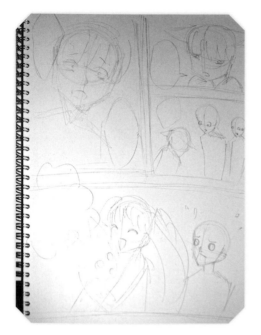

1 Plan out the story you want to tell by creating a draft script with only stick figures and speech balloons with text.

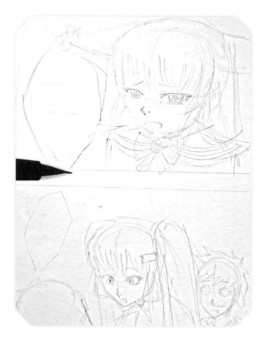

2 On a larger piece of paper, size A4 (letter) or larger, use a pencil to draw the figures in more detail by giving their bodies shape and their faces emotions.

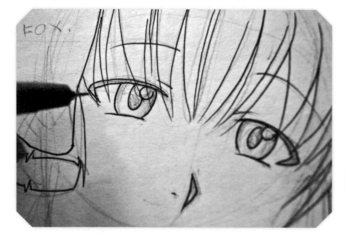

3 With a thin marker or Multiliner pen, ink in the lines on the characters and borders.

4 Use a ruler to draw the precise straight lines for the borders of each image box.

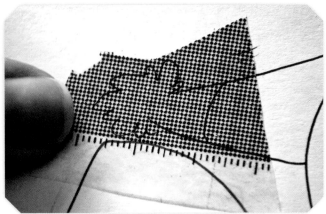

5 Fill in the larger black areas using a black permanent marker.

6 Screentone or crosshatching is used to add gray shades. Screentone will be further explained in the next chapter.

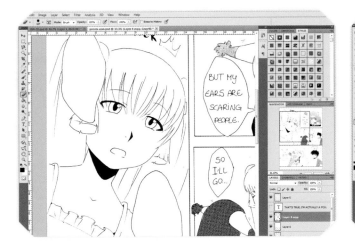

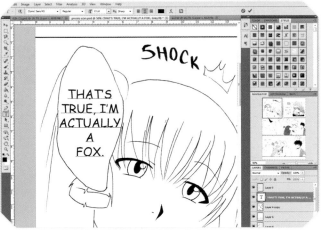

7 When the manga panel is done, you can use Adobe® Photoshop® software or another photo editing program to erase the handwritten text and add some contrast to the panel.

Use Capital Letters

Comic text is usually in all caps.

This is what the finished page looks like. You will learn how to make it completely, piece by piece, by using the lessons ahead in this book.

Since you probably do not live in Japan, your manga panel will be read from left to right.

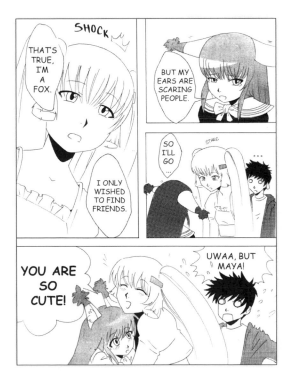

VISIT **IMPACT-BOOKS.COM/MANGA-CRASH-COURSE** FOR BONUS CONTENT.

17

2

THE
Basics

The secret to drawing manga is simplicity. In this chapter you will learn how to draw eyes, faces and bodies of both male and female characters. These lessons will help you draw your future characters with ease. We will learn how to simplify the body so your characters have the real manga look.

Drawing Manga Eyes

This is the basic pattern for all the different types of eyes. Almost all manga eyes have these parts and lines. We can use these rules to make both a female and male eye, plus sad, happy and other types of eyes. This first eye is usually used to draw cute girls.

MATERIALS

crayons, colored pencils, markers or watercolor paint

eraser

paper

pencil

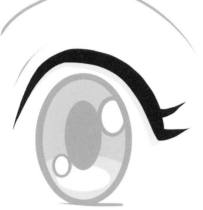

1 Draw the thick upper eyelashes as one line (marked in red). If you're drawing a female eye, add a few lashes at the corner.

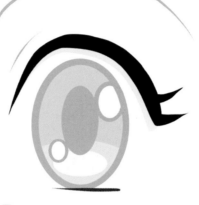

2 Add the thin lower lash line where the bottom of the eye will be.

3 The crease of the eyelid is created by drawing a short, thin line above the upper lash line.

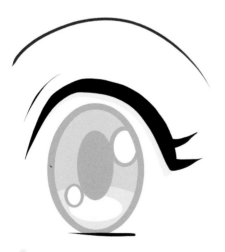

4 Draw a long, thin curved line above the crease and lash line to create a female eyebrow.

5 Draw an oval-shaped iris that touches the lower lash line but not the upper lash line.

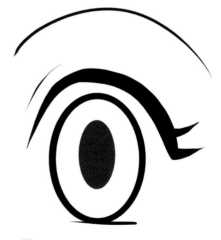

6 Draw an oval-shaped pupil inside the iris.

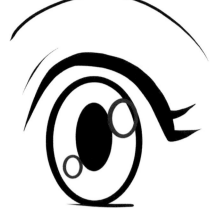

7 Make two catch-light bubbles in the iris, one bigger and one smaller.

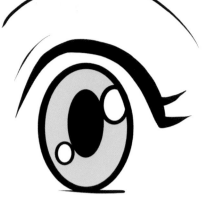

8 Color all of the iris a color of your choice, but leave the circles white.

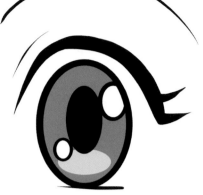

9 Color most of the iris with a darker shade of the eye color.

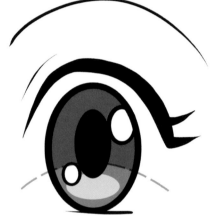

10 Use an even darker shade of the iris color and color above the dotted line (added as a guide), giving the eye depth and dimension.

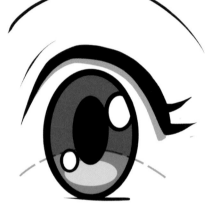

11 Add a gray shadow under the upper eyelashes.

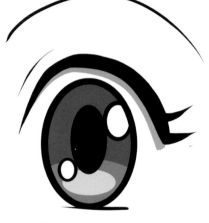

12 Remove the dotted line or other extra sketch marks. Now you have a whole manga eye!

VISIT IMPACT-BOOKS.COM/MANGA-CRASH-COURSE FOR BONUS CONTENT.

21

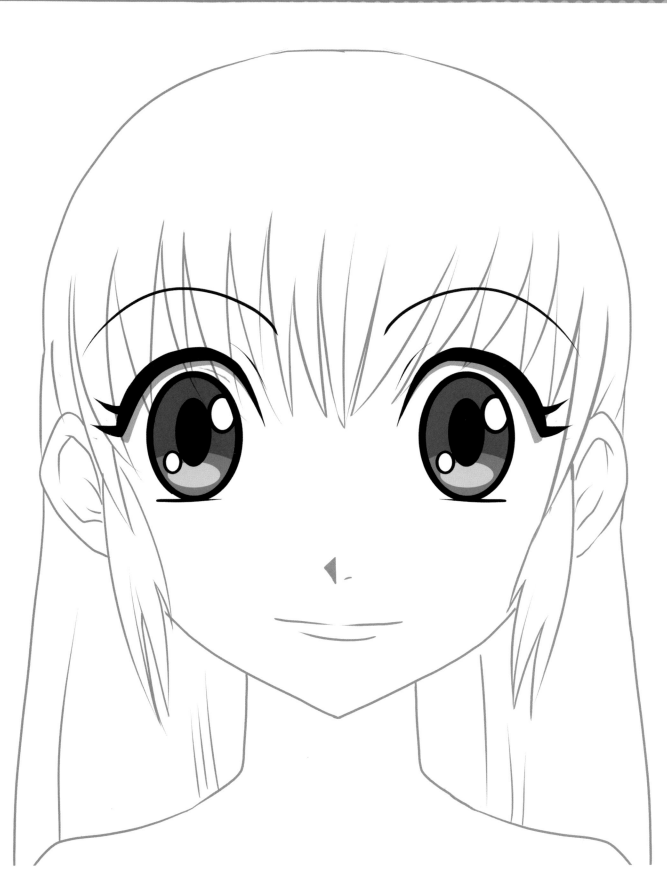

Female eyes are usually larger, with more light "bubbles" inside, more eyelashes and thinner eyebrows. Female eyebrows are set farther away from the eyes. Pupils are large and can be colored as well as have a lot of different shapes and sizes.

Male Manga Eyes

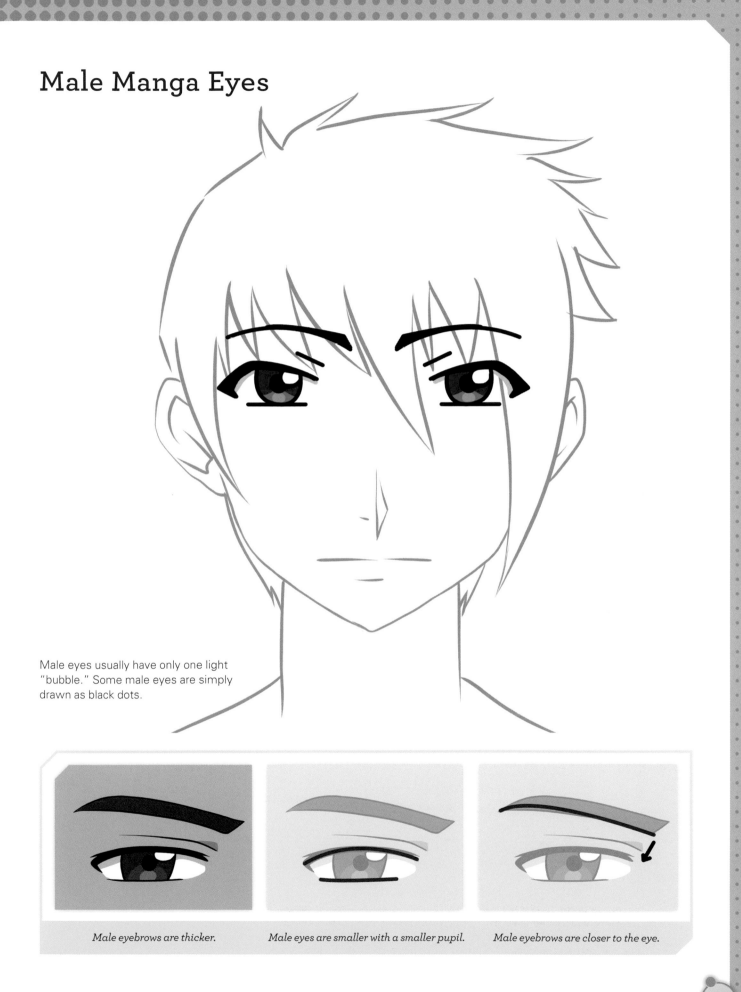

Male eyes usually have only one light "bubble." Some male eyes are simply drawn as black dots.

Male eyebrows are thicker.

Male eyes are smaller with a smaller pupil.

Male eyebrows are closer to the eye.

VISIT IMPACT-BOOKS.COM/MANGA-CRASH-COURSE FOR BONUS CONTENT.

23

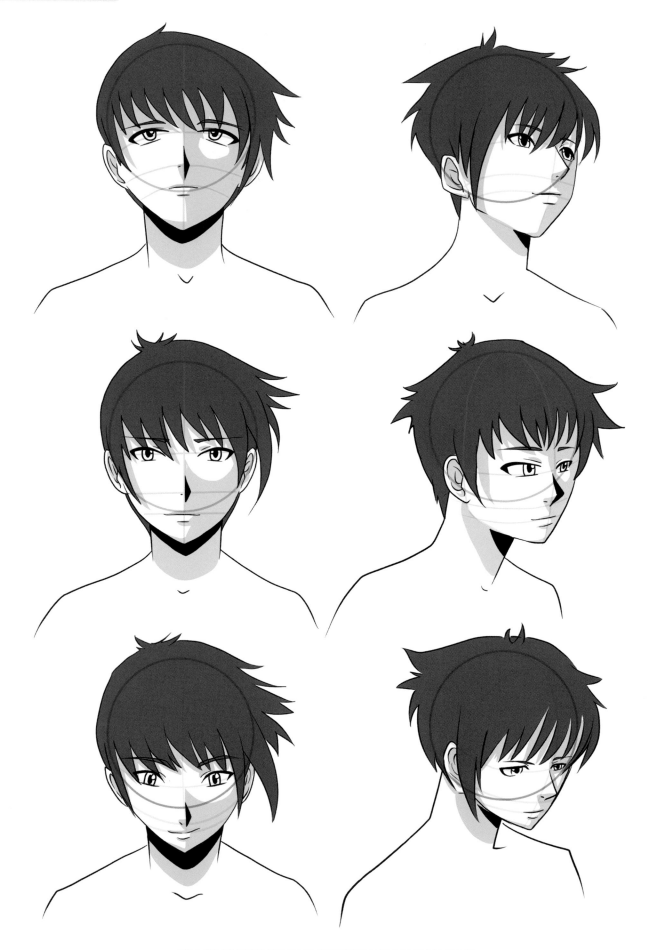

Male Manga Face

A male face in manga is mostly created with sharper angles, smaller eyes and a longer chin than the female face. To draw a male face, just follow these steps.

MATERIALS

eraser

paper

pen or pencil

Front View

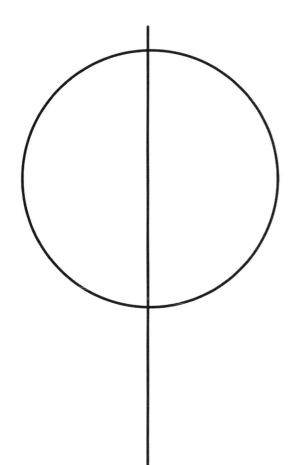

1 Draw a circle. Split it in half vertically.

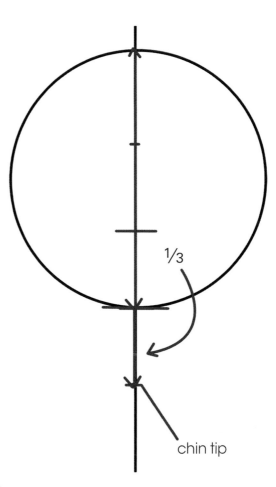

⅓

chin tip

2 Place a pointed chin tip below the circle at one-third the diameter of the circle.

VISIT **IMPACT-BOOKS.COM/MANGA-CRASH-COURSE** FOR BONUS CONTENT.

25

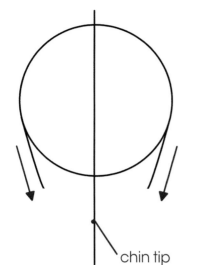

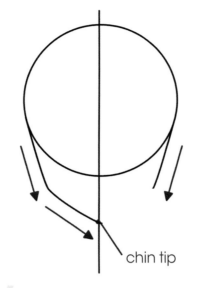

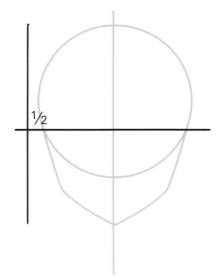

3 Draw two lines out from the circle, leaning toward the chin tip.

4 Angle the lines before connecting them at the chin tip.

5 Split the whole face (not just the circle) in half horizontally. This is where the eyes will be.

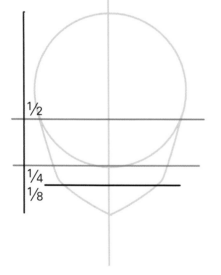

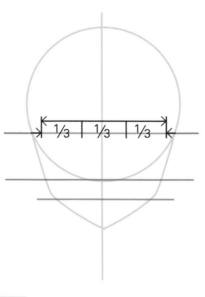

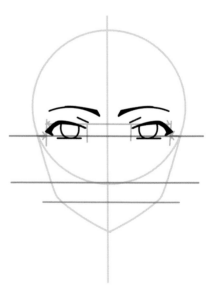

6 Split the bottom half of the face in half to get the line for the placement of the nose (¼ line). Split the bottom in half again to find where to draw the mouth (⅛ line).

7 Divide the eye line into thirds, reserving some extra space on outside edges.

8 Draw eyes in the outside thirds of the line. Leave the center third open. There should always be room for a whole eye between the eyes.

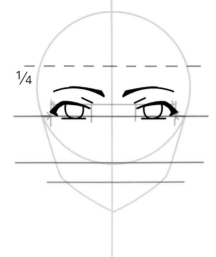

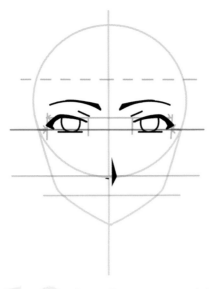

9 To find the forehead, divide the upper half of the face (¼ line).

10 Draw the nose as a dot and a triangle on the nose line.

11 Draw the mouth as a straight line on the mouth line, with a smaller line under it.

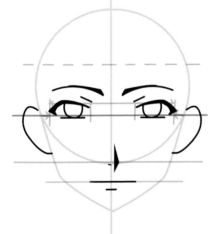

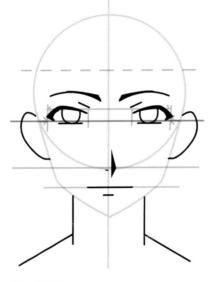

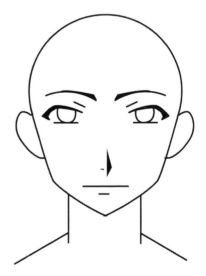

12 Draw the ears as C-shapes on the side of the face between the nose and the eye line.

13 The neck is drawn half as wide as the face. Add two tilted lines at the bottom of the necklines to create the shoulders.

14 Remove any sketch marks or grid lines. Now you have a complete male manga face.

¼

Coming Up!

See Chapter 3 for examples of how to draw different mouths, noses and ears for different characters.

Side View

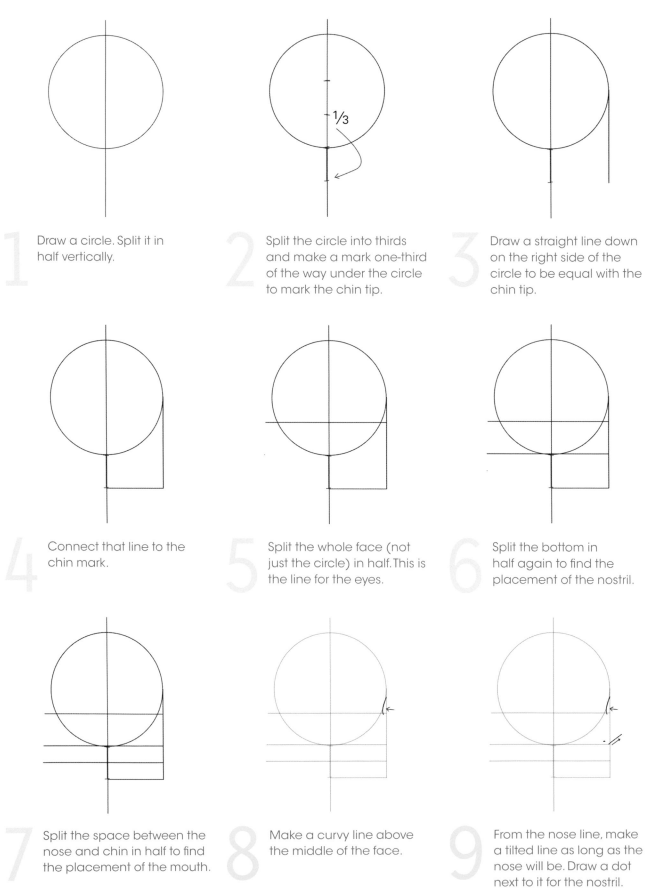

1. Draw a circle. Split it in half vertically.

2. Split the circle into thirds and make a mark one-third of the way under the circle to mark the chin tip.

 1/3

3. Draw a straight line down on the right side of the circle to be equal with the chin tip.

4. Connect that line to the chin mark.

5. Split the whole face (not just the circle) in half. This is the line for the eyes.

6. Split the bottom in half again to find the placement of the nostril.

7. Split the space between the nose and chin in half to find the placement of the mouth.

8. Make a curvy line above the middle of the face.

9. From the nose line, make a tilted line as long as the nose will be. Draw a dot next to it for the nostril.

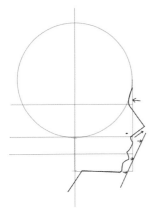

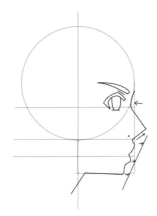

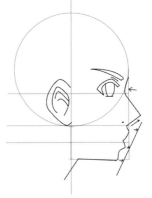

10 Connect the bottom nose line to the curved line above to make the full nose.

Connect the nose to the chin by adding curved lines for the lips.

11 Place the eye at the halfway line on the face.

12 Draw the ear on the left side of the vertical halfway line. It should be placed between the eyebrow and the nose height.

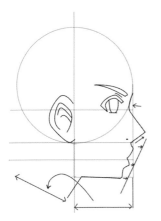

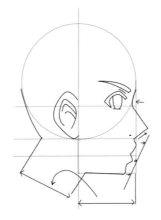

13 The front of the neck should start at the chin line and the vertical halfway line. Angle the line away from the face.

14 Connect the back of the neck to the circle at the height of the nose.

Erase all the guidelines and sketch marks to reveal the completed side face.

An Angled Face

In a side view of a manga face, the nose is the longest, then the upper lip, the lower lip and the chin.

Three-Quarter View

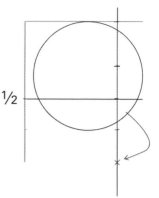

chin tip

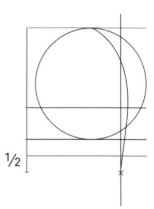

½

1 Draw a circle and make a vertical line on the side of it, one quarter of the diameter.

2 Add a mark one-third of the diameter of the circle under the circle to make a chin tip.

3 Split the entire face (not just the circle) in half horizontally. This is where the eyes will be drawn.

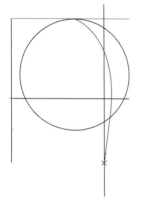

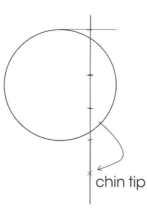

½

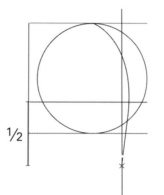

½

4 The middle of the three-quarter view face is a curved line. It starts on the top of the circle, curves to meet the vertical line and ends at the chin tip.

5 Divide the lower half of the face to mark where the nose will be.

6 Mark the halfway point between the nose and chin tip to find the placement of the mouth.

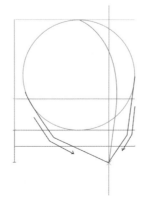

7 Draw a diagonal line from each side of the circle's edge to the nose line. At the nose line, angle the lines further until they meet at the chin tip.

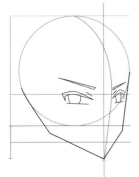

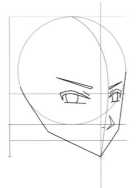

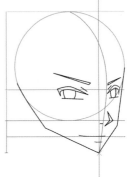

8 Draw the eyes on the horizontal halfway line of the face. Allow enough space between the eyes to draw a whole eye.

9 Draw the nose between the eyes and chin height lines.

10 Draw the mouth between the nose and the chin.

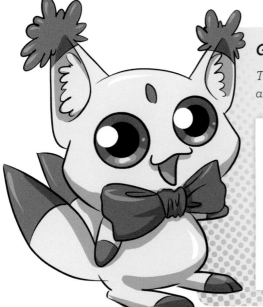

Get Some Perspective

The eye closer to us is normal size, and the other one is half as wide.

1/2

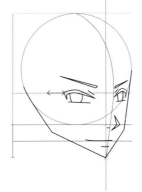

11 The ear needs some space away from the eye. Where the chin line bends is a good place to start.

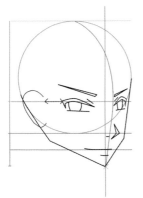

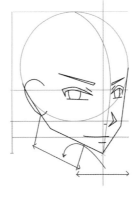

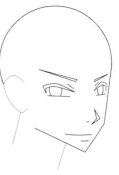

12 Draw the ear between the nose and eyebrow height.

13 The neck is as wide as half of the head. It ends right under the ear.

14 Erase all the guidelines to reveal the complete male manga head.

VISIT IMPACT-BOOKS.COM/MANGA-CRASH-COURSE FOR BONUS CONTENT.

31

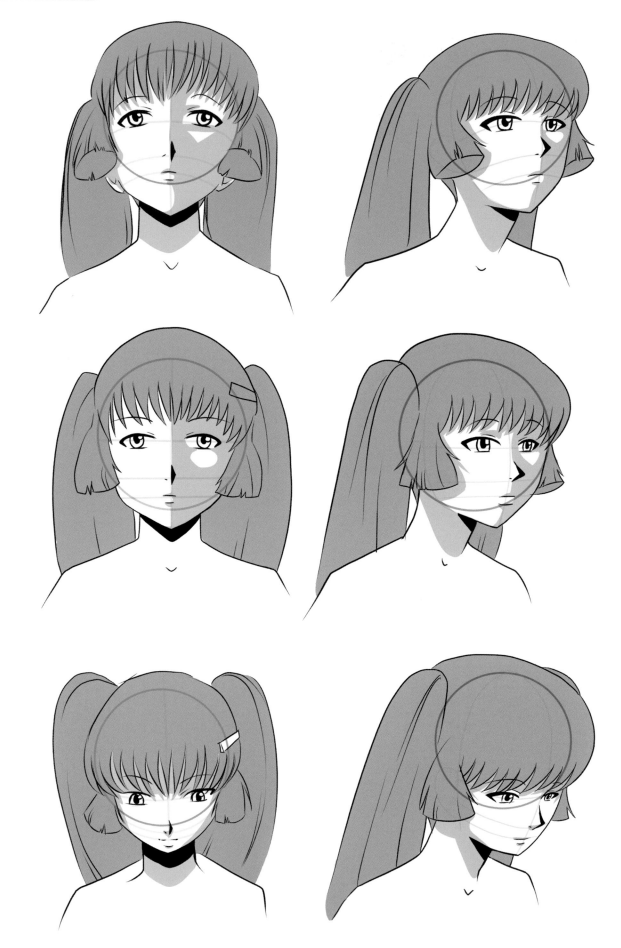

Female Manga Face

Female faces in manga mostly look like the face of a doll, with a round face, huge eyes and a small pouty mouth. To achieve this look, just follow these steps.

>> MATERIALS

eraser

paper

pen or pencil

Front View

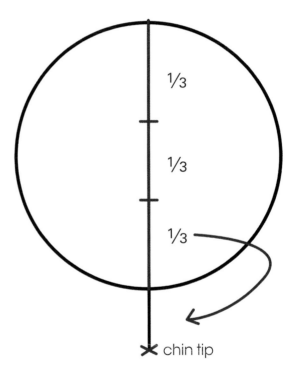

1/3

1/3

1/3

 chin tip

1 Draw a circle and split it in half vertically.

2 Add a mark one-third of the diameter of the circle under the circle to make a chin tip.

VISIT IMPACT-BOOKS.COM/MANGA-CRASH-COURSE FOR BONUS CONTENT.

33

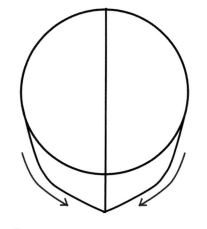

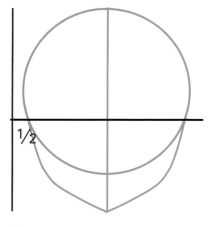

3 Slide a line from the circle, and curve it downward to connect it with the chin tip.

4 Repeat step 3 on the opposite side of the face to complete the chin.

5 Split the whole face (not just the circle) in half horizontally. This is where the eyes will be placed.

1/2

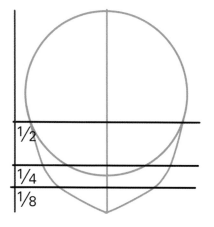

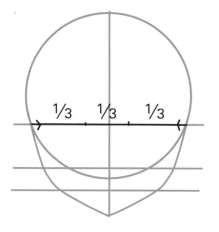

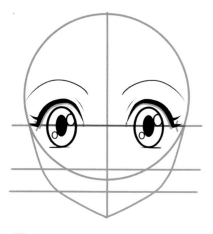

1/2
1/4
1/8

1/3 1/3 1/3

6 Split the bottom half of the face in half again to get the nose line. Split the bottom in half again to find where to draw the mouth.

7 Divide the eye line into thirds, leaving a little extra space on either side.

8 Put the eyes on the middle line. There should always be room for a whole eye between the eyes.

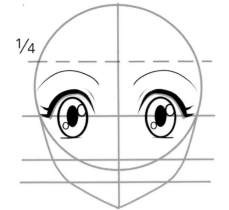

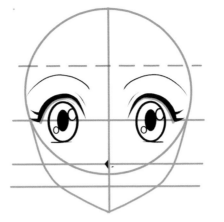

1/4

9 To find the forehead, divide the upper half of the face.

10 Draw the nose as a dot and a triangle on the nose line.

11 Draw the mouth as a straight line on the mouth height, with a smaller line under it.

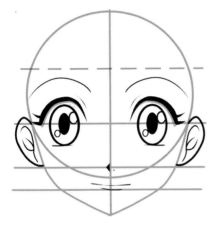

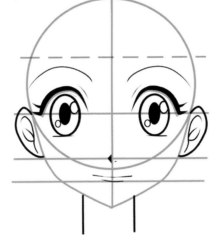

12 Draw the ears as C-shapes on the side of the face between the nose and the eyes' height.

13 The neck is as wide as a third of the face and can be drawn as two straight lines.

14 Erase all of your guidelines. Now you have a complete female manga face.

Coming Up...

You'll find more ways to draw noses, mouths and ears in the next chapter!

VISIT **IMPACT-BOOKS.COM/MANGA-CRASH-COURSE** FOR BONUS CONTENT.

35

Side View

1 Draw a circle and split it in half vertically.

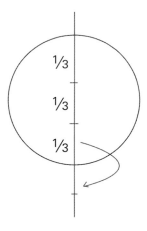

2 Add a mark one-third of the diameter of the circle under the circle to make a chin tip.

3 Draw a straight line down on the right side of the circle to be equal with the chin tip.

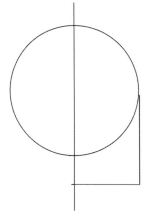

4 Connect that line to the chin mark.

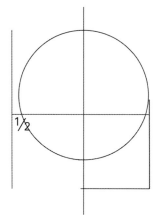

5 Split the whole face (not just the circle) in half horizontally. This is the line where the eye will be placed.

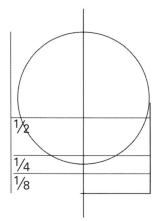

6 Split the bottom in half again to find where the nostril will be. Divide the bottom in half again for the mouth line.

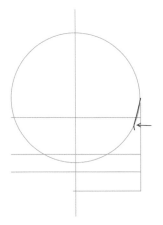

7 Make a curved line inside the circle at the halfway line.

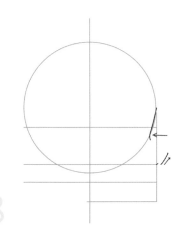

8 At the nose line, make a tilted line angling up and out. This will be the length of the nose. Draw a dot next to it for the nostril.

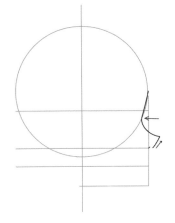

9 Connect the top of the nose line to the curved line you just drew with another curved line.

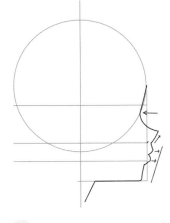

10 Draw several curved lines to make lips and connect the nose to the chin tip.

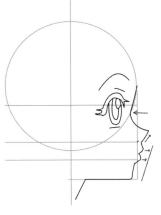

11 Draw the eye on the eye line (the face's halfway line) that you created earlier. Don't forget to add the eyelashes as part of the girl's eye!

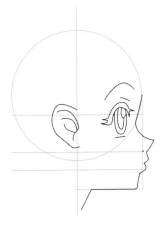

12 Draw the ear on the back half of the face midway between the eyebrow and the nose height.

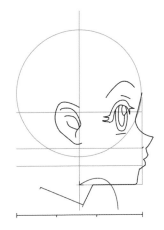

13 The neck is as wide as a third of the head. Draw a downward angled line from the bottom of the chin.

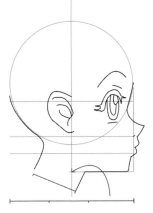

14 Connect the back of the neck to the circle at the height of the nose.
Erase all of your guidelines to reveal the completed face.

Angled Face Reminder

Remember the rule for manga faces: The nose is the longest, then the upper lip, the lower lip and the chin.

Three-Quarter View

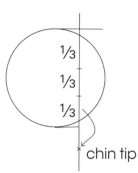

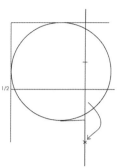

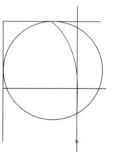

1 Draw a circle. Make a vertical line on the side of the circle, one quarter of the diameter. Add a mark one-third of the diameter of the circle under the circle to mark the chin tip.

2 Split the face (not the circle) in half. This is where the eyes will be.

3 Mark the center of the face with a curved line. It starts at the top of the circle and ends at the chin tip.

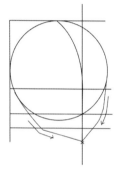

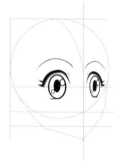

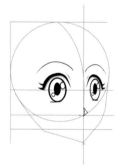

4 Mark guidelines for the nose and mouth. The nose will be in the lower quarter of the face. The mouth is located halfway between the nose and the chin tip.

5 Draw the eyes at the guideline made earlier. The distance between the two eyes should be the same size as a whole eye.

6 Draw the nose as a dot and a triangle at the nose line. The eye closer to us is normal size, and the other one is half as wide because of the perspective.

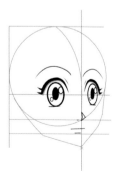

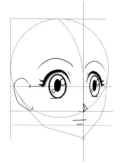

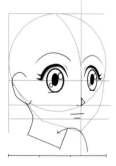

7 Draw the mouth between the nose and the chin.

8 The ear needs some space away from the eye. Draw the ear between the nose and eyebrow height.

9 The neck is as wide as a third of the head. It ends right under the ear.
 Erase your guidelines to reveal the complete female manga head.

BASIC MANGA BODY—COUNTING HEADS

The height of a head can be used to measure the overall height of your manga characters and can help prevent you from making the hands or legs too small or too short. The more heads you add, the taller the character will be. Make a small manga character 2 heads tall for a chibi, or 6 or 7 heads tall for an adult character.

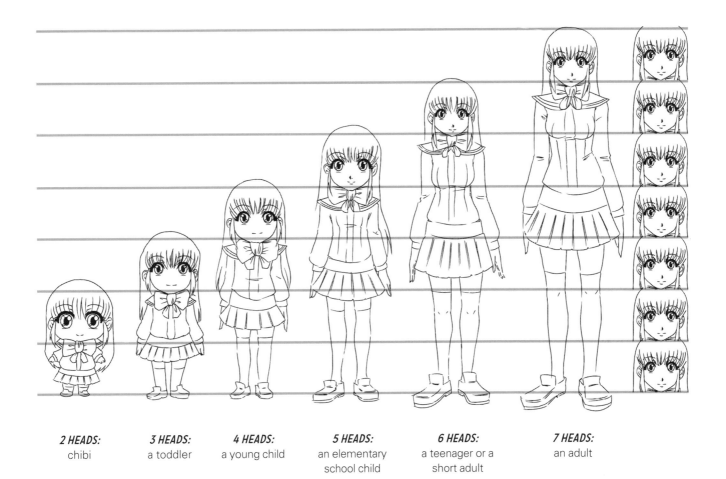

2 HEADS:
chibi

3 HEADS:
a toddler

4 HEADS:
a young child

5 HEADS:
an elementary
school child

6 HEADS:
a teenager or a
short adult

7 HEADS:
an adult

VISIT IMPACT-BOOKS.COM/MANGA-CRASH-COURSE FOR BONUS CONTENT.

39

CHIBIS

"Chibi" means "small" in Japanese. Chibis are cute, tiny characters, and the same chibi body can be used for both female and male characters.

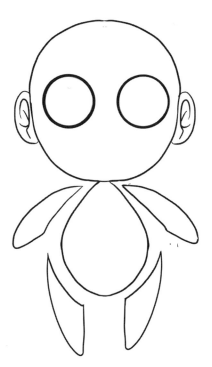

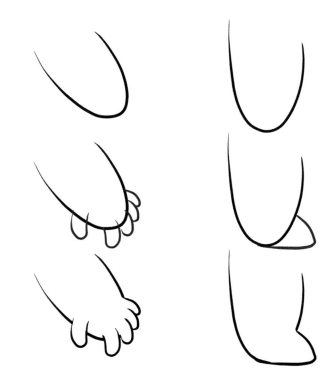

Every part of a chibi is drawn as a curved shape.

To draw a chibi hand, add tiny u-shapes to the end of the arm to create fingers.

Chibi legs can be u-shaped, or you can add a tiny foot.

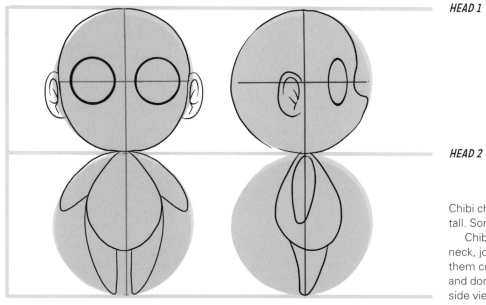

HEAD 1

HEAD 2

Chibi characters are about 2 heads tall. Some can be a bit taller.

Chibi characters usually have no neck, joints or shoulders. To make them cuter, give them very large eyes and don't draw a nose except from a side view.

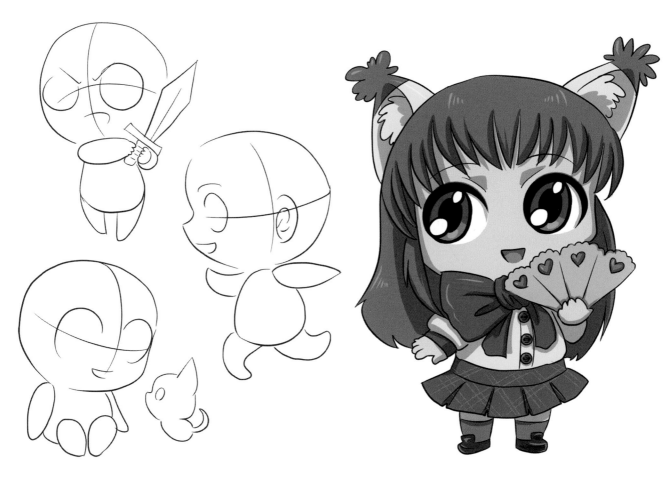

Even when chibi characters move, they are made from curvy shapes.

The more details you put on the clothes and shoes, the better the chibi will look.

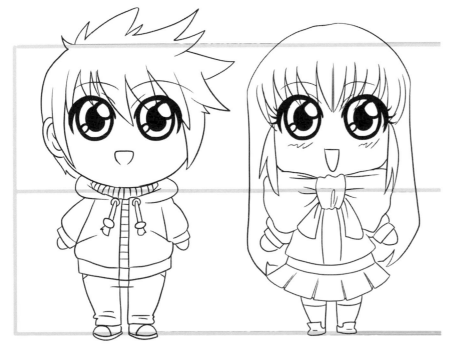

The rules for drawing the bodies of chibi characters are the same for both girls and boys. The differences will be seen in their clothes and hairstyles.

VISIT **IMPACT-BOOKS.COM/MANGA-CRASH-COURSE** FOR BONUS CONTENT.

41

AGING YOUR CHARACTERS

Aging in manga is shown through small details, but the base of the head is always the circle.

Female Child

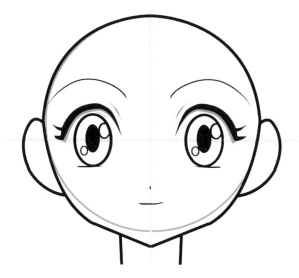

Male Child

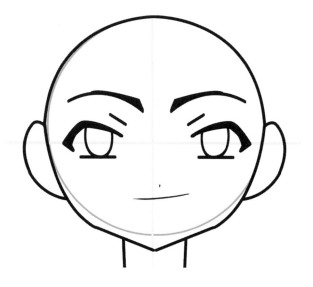

Children's faces are just a little longer than the base circle, and have bigger eyes than adults.

Female Teenager

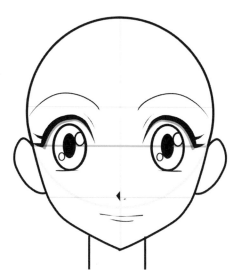

Male Teenager

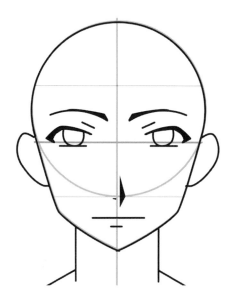

Teenagers have the face shape we covered earlier in this chapter.

Female Adult

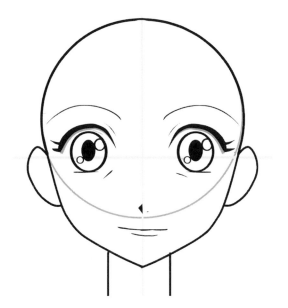

Male Adult

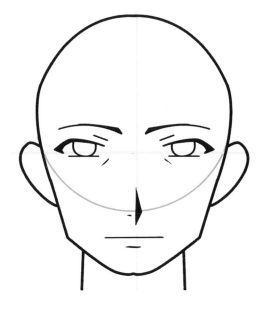

Adult faces have smaller eyes and added lines under the eyes. The same size face can be used for for adult females as the teen female face. Adult males have a longer chin than the teenage males.

Female Senior

Male Senior

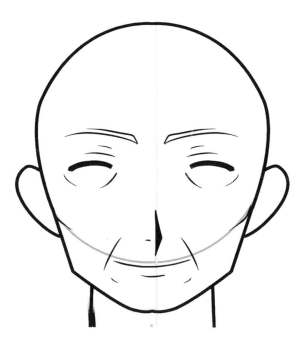

For senior adults, the head is flattened to be shorter than the teenage face, with lots of wrinkles near the eyes and mouth.

VISIT **IMPACT-BOOKS.COM/MANGA-CRASH-COURSE** FOR BONUS CONTENT.

43

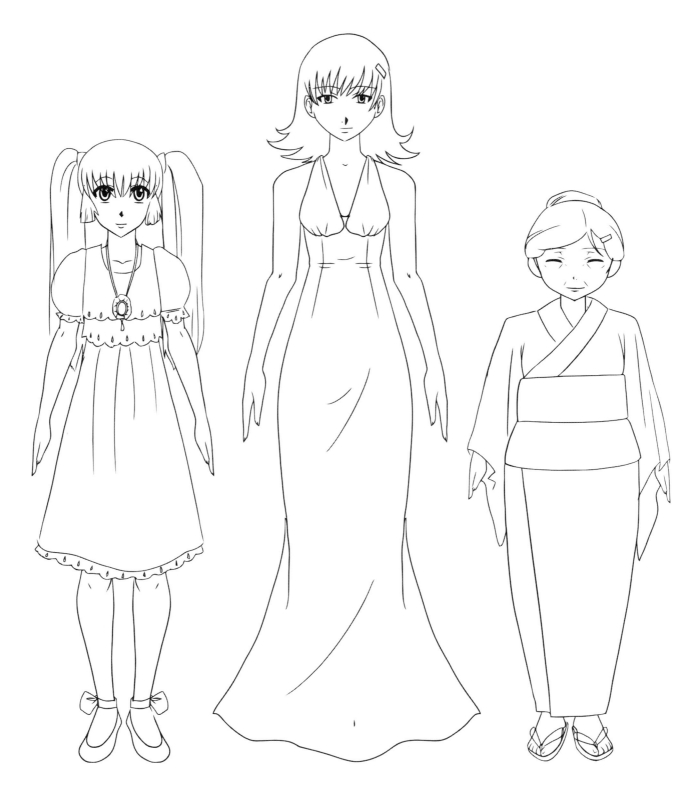

Teenage girls in manga are short and don't have many curves.

Adult females are about 7 heads tall and have curvy bodies.

A senior female in manga is usually drawn really short and kind of chubby rather than curvy.

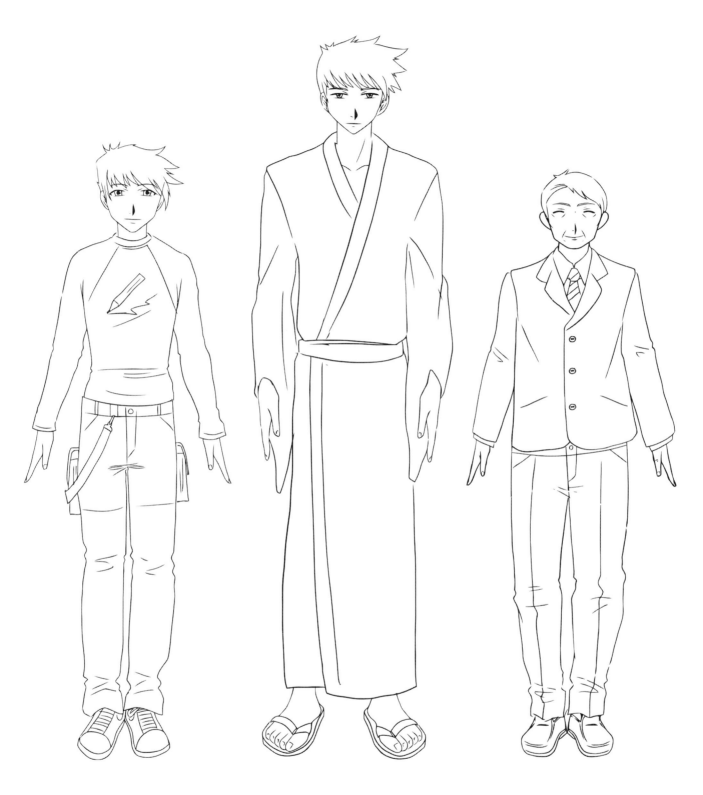

Teenage boys are slender with a young, skinny body.

Adult males can be drawn really tall, with a longer neck and more muscles.

Senior males in manga are usually drawn short, a bit wider and with a bigger forehead to show hair loss.

VISIT IMPACT-BOOKS.COM/MANGA-CRASH-COURSE FOR BONUS CONTENT.

45

ANATOMY

To be able to draw the manga body, we need to know the real body first. Real Western people typically range from 7 to 10 heads tall. Bones in the human skeleton each have distinct shapes that help give the body its structure. The second thing that shapes the look of the body are the muscles. All the muscles in the human body have their own place and function. When the body moves, some muscles change their shape.

Practice: Observe the people around you and sketch them, their movements, the shapes of their hands, legs and shoulders. The more you practice, the better you will get.

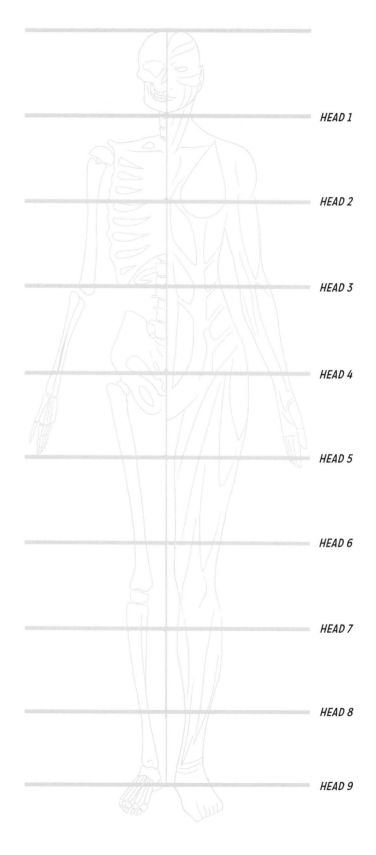

HEAD 1

HEAD 2

HEAD 3

HEAD 4

HEAD 5

HEAD 6

HEAD 7

HEAD 8

HEAD 9

SIMPLIFY FOR MANGA STYLE

Adult manga bodies are usually 6 to 8 heads tall.
After we count the heads properly and put everything
in its place, we need to create the shape of the body.
Instead of drawing a skeleton and muscles, simple
lines and basic shapes are all we need. After the lines
are set up, we can make the body look natural by
using basic shapes, such as circles for the joints and
cylinders for the hands and legs.

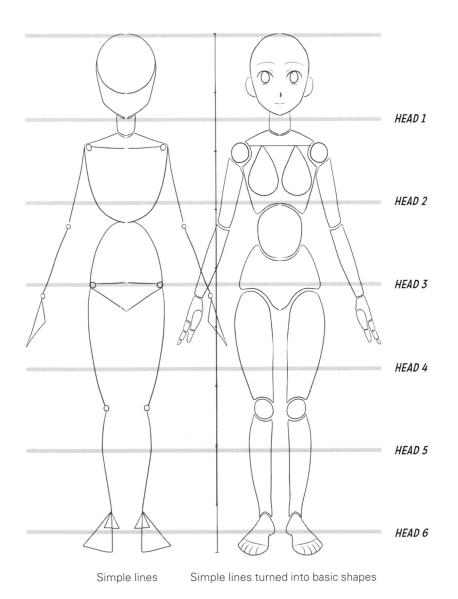

HEAD 1

HEAD 2

HEAD 3

HEAD 4

HEAD 5

HEAD 6

Simple lines Simple lines turned into basic shapes

VISIT IMPACT-BOOKS.COM/MANGA-CRASH-COURSE FOR BONUS CONTENT.

47

Male Body Shaping Technique:
Teenager

In this lesson we will learn how to draw a teenage male character.

MATERIALS

eraser

paper

pen or pencil

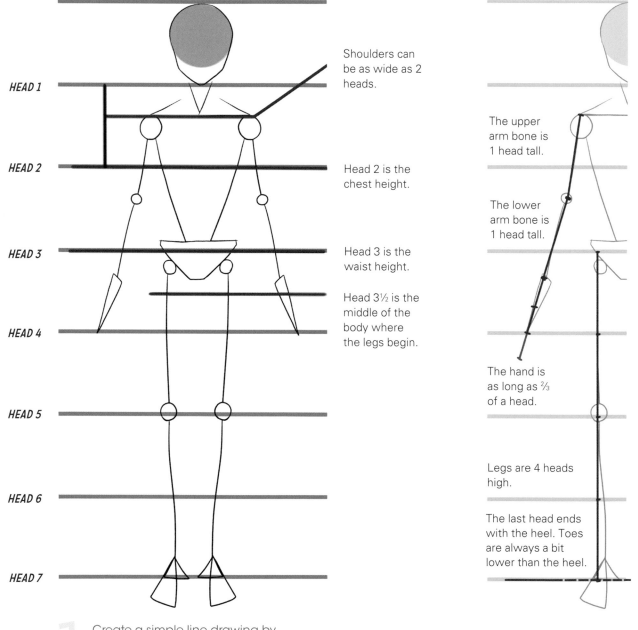

HEAD 1

HEAD 2

HEAD 3

HEAD 4

HEAD 5

HEAD 6

HEAD 7

Shoulders can be as wide as 2 heads.

Head 2 is the chest height.

Head 3 is the waist height.

Head 3½ is the middle of the body where the legs begin.

The upper arm bone is 1 head tall.

The lower arm bone is 1 head tall.

The hand is as long as ⅔ of a head.

Legs are 4 heads high.

The last head ends with the heel. Toes are always a bit lower than the heel.

1 Create a simple line drawing by sketching body parts at the appropriate head level.

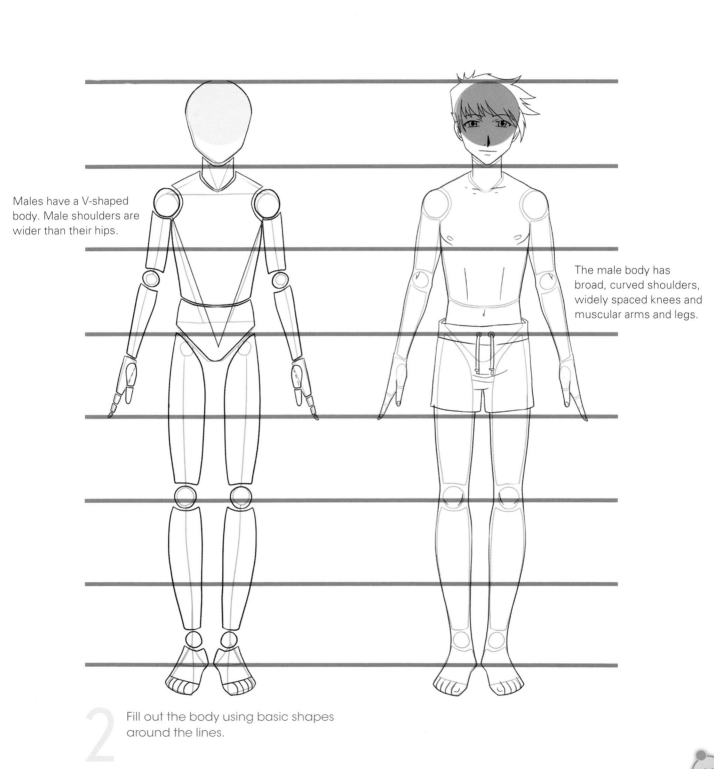

Males have a V-shaped body. Male shoulders are wider than their hips.

The male body has broad, curved shoulders, widely spaced knees and muscular arms and legs.

2 Fill out the body using basic shapes around the lines.

Male Body Shaping Technique: Adult

In this lesson we will learn how to draw an adult male character.

MATERIALS

eraser

paper

pen or pencil

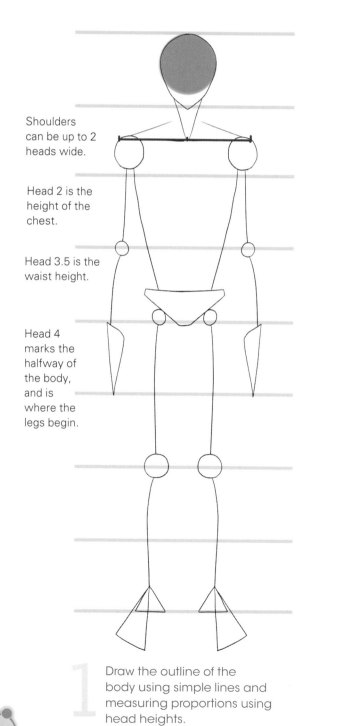

Shoulders can be up to 2 heads wide.

Head 2 is the height of the chest.

Head 3.5 is the waist height.

Head 4 marks the halfway of the body, and is where the legs begin.

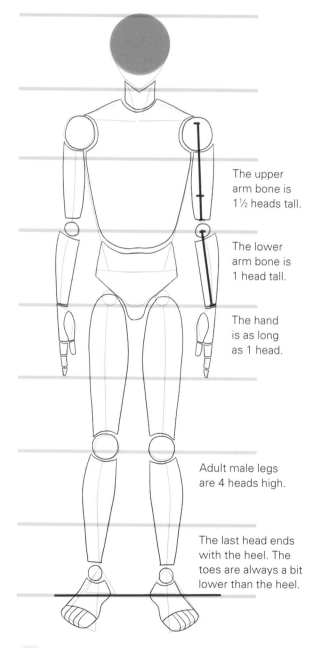

The upper arm bone is 1½ heads tall.

The lower arm bone is 1 head tall.

The hand is as long as 1 head.

Adult male legs are 4 heads high.

The last head ends with the heel. The toes are always a bit lower than the heel.

1 Draw the outline of the body using simple lines and measuring proportions using head heights.

2 Give dimension to the body using simple shapes around the outline.

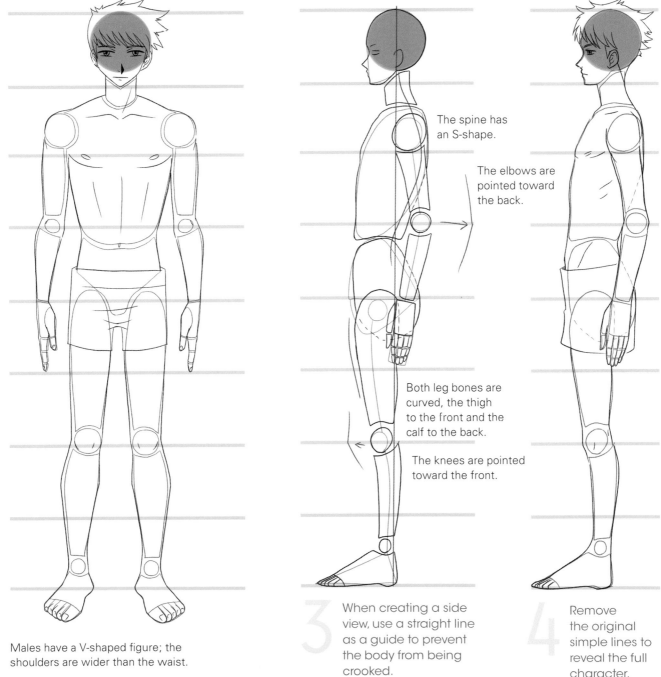

The spine has an S-shape.

The elbows are pointed toward the back.

Both leg bones are curved, the thigh to the front and the calf to the back.

The knees are pointed toward the front.

Males have a V-shaped figure; the shoulders are wider than the waist.

3 When creating a side view, use a straight line as a guide to prevent the body from being crooked.

4 Remove the original simple lines to reveal the full character.

Female Body Shaping Technique: Teenager

In this lesson we will learn how to draw a teenage female character.

MATERIALS

eraser

paper

pen or pencil

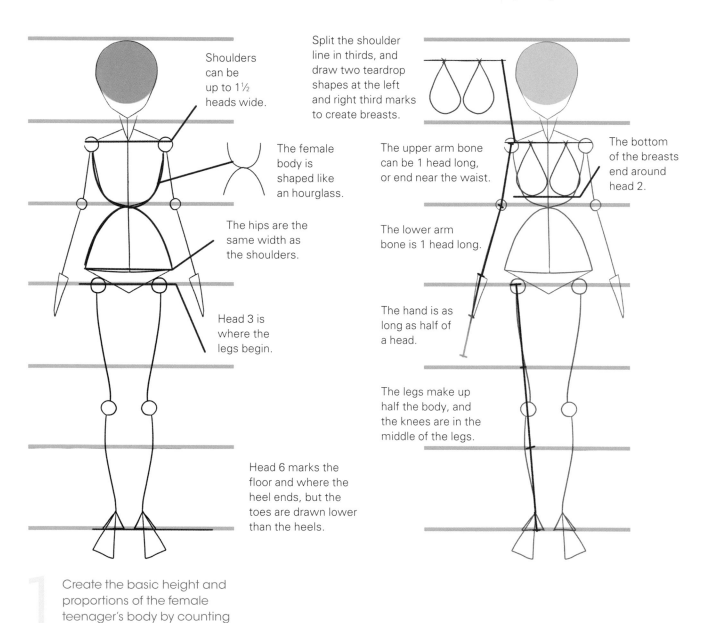

Shoulders can be up to 1½ heads wide.

The female body is shaped like an hourglass.

The hips are the same width as the shoulders.

Head 3 is where the legs begin.

Split the shoulder line in thirds, and draw two teardrop shapes at the left and right third marks to create breasts.

The upper arm bone can be 1 head long, or end near the waist.

The lower arm bone is 1 head long.

The hand is as long as half of a head.

The legs make up half the body, and the knees are in the middle of the legs.

The bottom of the breasts end around head 2.

Head 6 marks the floor and where the heel ends, but the toes are drawn lower than the heels.

1 Create the basic height and proportions of the female teenager's body by counting heads and drawing simple lines.

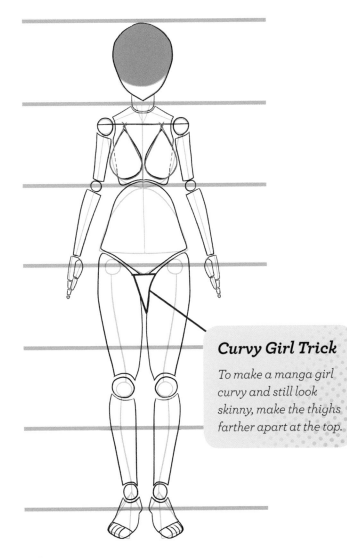

Curvy Girl Trick

To make a manga girl curvy and still look skinny, make the thighs farther apart at the top.

2 Fill out the body by drawing simple shapes around the basic lines. Remember, females have a curvier body, tiny hands and closer knees.

3 In manga, the body is exaggerated to make girls look more like dolls. The neck is a bit thinner, shoulders are more narrow and the waist can be drawn much slimmer than a real girl's.

Female Body Shaping Technique: Adult

In this lesson we will learn how to draw an adult female manga character.

MATERIALS

eraser

paper

pen or pencil

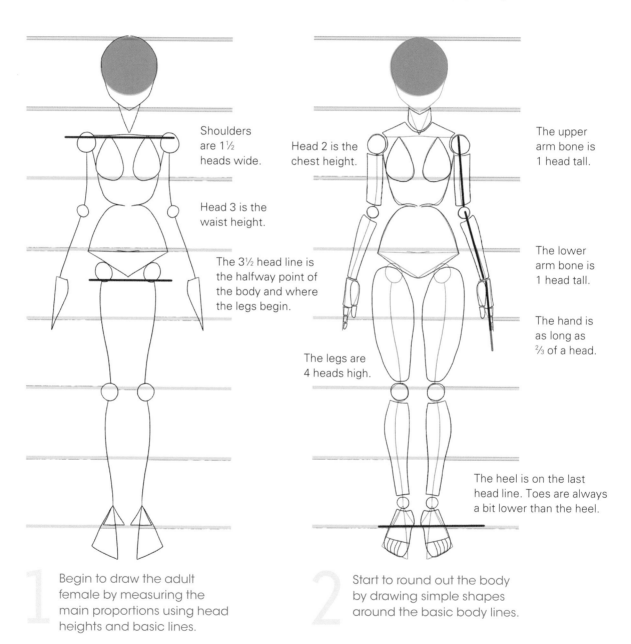

Shoulders are 1½ heads wide.

Head 3 is the waist height.

The 3½ head line is the halfway point of the body and where the legs begin.

Head 2 is the chest height.

The upper arm bone is 1 head tall.

The lower arm bone is 1 head tall.

The hand is as long as ⅔ of a head.

The legs are 4 heads high.

The heel is on the last head line. Toes are always a bit lower than the heel.

1 Begin to draw the adult female by measuring the main proportions using head heights and basic lines.

2 Start to round out the body by drawing simple shapes around the basic body lines.

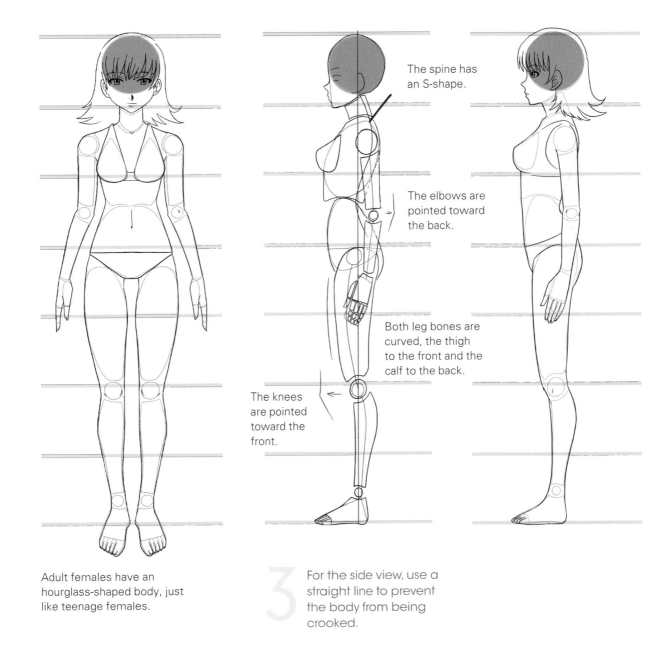

The spine has an S-shape.

The elbows are pointed toward the back.

Both leg bones are curved, the thigh to the front and the calf to the back.

The knees are pointed toward the front.

Adult females have an hourglass-shaped body, just like teenage females.

3 For the side view, use a straight line to prevent the body from being crooked.

VISIT IMPACT-BOOKS.COM/MANGA-CRASH-COURSE FOR BONUS CONTENT.

55

3 Details

Eyes, noses, mouth, ears—these are the details on the face. In this chapter you will learn about different shapes of the details and how changing them changes the manga face and your characters. Adding some cool haircuts, clothes and accessories will make your characters look original and appealing.

NOSE SHAPES

Female manga characters have extremely small noses and tiny nostrils drawn close together. Men have bigger noses, but try to keep the nostrils close together for attractive characters. For older people and funny characters, the nostrils are wider and bigger. When you draw a cute character, like a sweet girl, sometimes you don't even need to draw a nose at all—it makes her cuter, and makes her eyes more noticeable.

Front View Side View

Female Noses

Male Noses

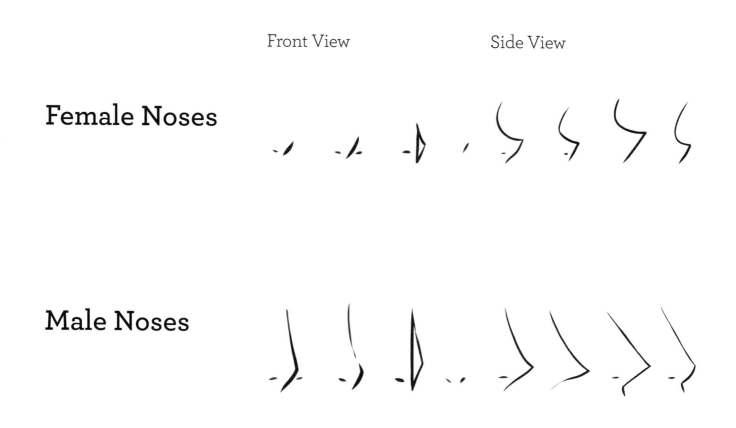

Noses

Manga noses are pretty simple to draw. You just need to know where to put them.

MATERIALS

paper

pencil

1 There are two basic types of manga noses. One type has just a tiny tapered line for the nostril.

2 For a more defined nose, draw a triangle or another tiny line next to the first line.

Pencil Pressure

Be careful with the pressure on the lines. Make the lines thicker as you get closer to the tip of the nose.

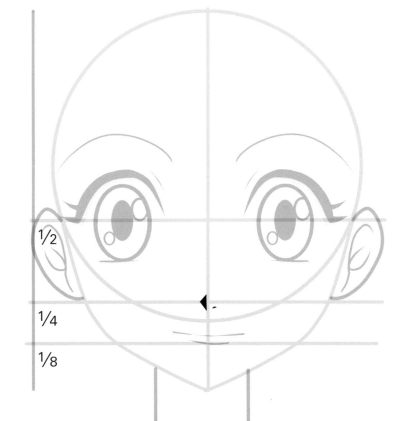

1/2

1/4

1/8

VISIT IMPACT-BOOKS.COM/MANGA-CRASH-COURSE FOR BONUS CONTENT.

59

MOUTH SHAPES

These are the very basic mouth shapes. When we draw emotions, the mouth can be drawn in a lot of different ways. In this section you will learn to draw basic mouth shapes. Later in this chapter (see the section about emotions) you'll learn how subtle changes can create different expressions on the face.

Female Mouth

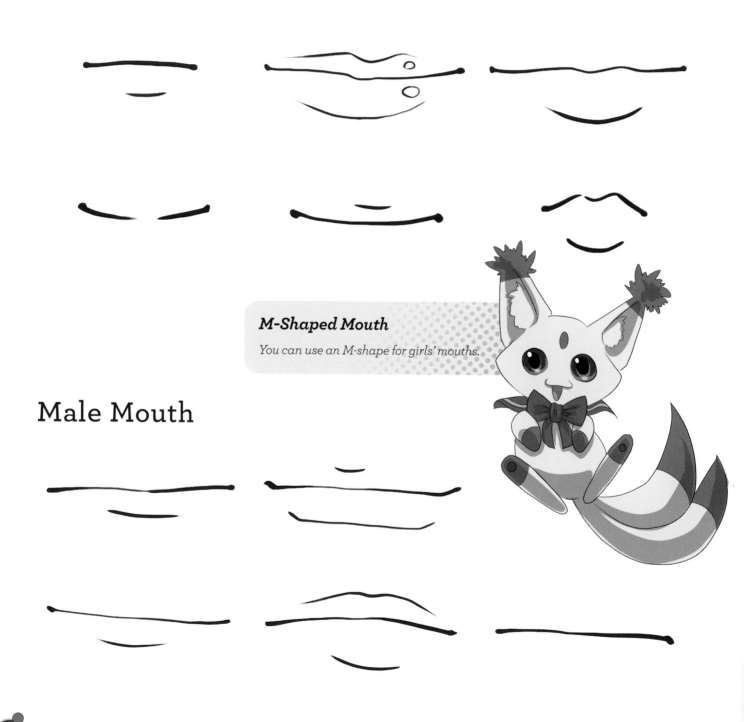

M-Shaped Mouth

You can use an M-shape for girls' mouths.

Male Mouth

Mouths

The mouth is drawn on the lower quarter of the face.

MATERIALS

eraser

paper

pencil or pen

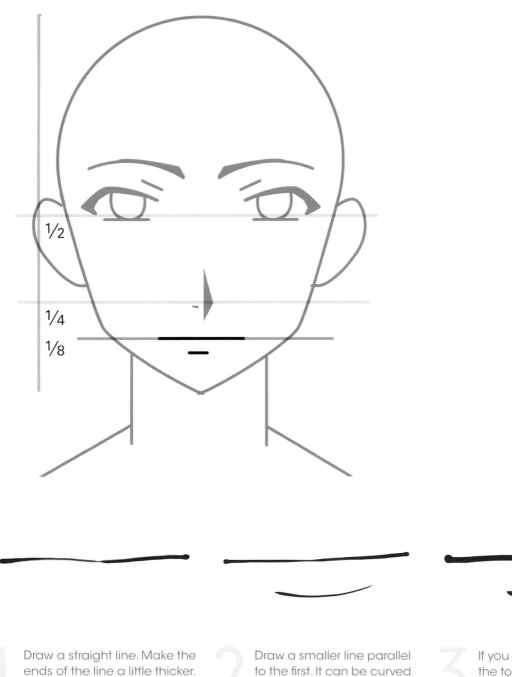

1/2

1/4

1/8

1 Draw a straight line. Make the ends of the line a little thicker.

2 Draw a smaller line parallel to the first. It can be curved instead of straight.

3 If you erase the middle of the top line, the mouth will look more pouty.

VISIT IMPACT-BOOKS.COM/MANGA-CRASH-COURSE FOR BONUS CONTENT.

61

EAR SHAPES

Ears are usually a part of the face people avoid drawing. Although they seem complicated to draw, that is far from the truth. Ears are what make the face realistic and your manga character look complete.

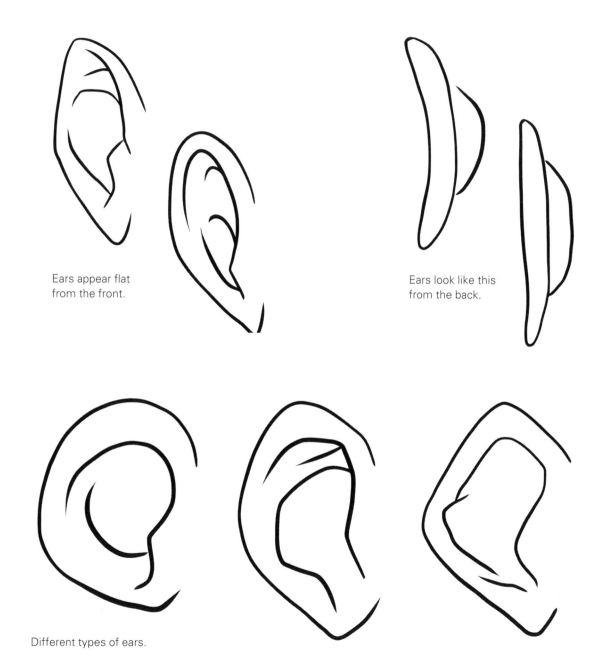

Ears appear flat from the front.

Ears look like this from the back.

Different types of ears.

Ears

Ears are drawn between the nose height and the eyebrow height. Some ears are smaller and some are larger.

MATERIALS

paper

pencil or pen

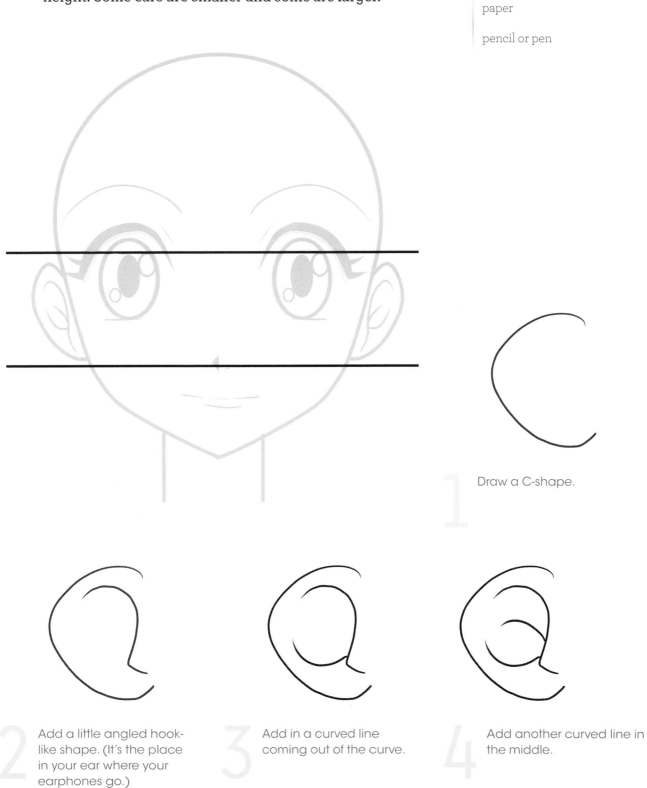

1 Draw a C-shape.

2 Add a little angled hook-like shape. (It's the place in your ear where your earphones go.)

3 Add in a curved line coming out of the curve.

4 Add another curved line in the middle.

VISIT IMPACT-BOOKS.COM/MANGA-CRASH-COURSE FOR BONUS CONTENT.

63

HAIR BASICS

Manga characters' hair tells us a lot about their personalities. A cool character has tidy hair, an adventurous character has spiky hair and a creative character has a hair that looks like a modern sculpture. Feel free to express your characters' personalities by making their hair color and shape as fun as possible.

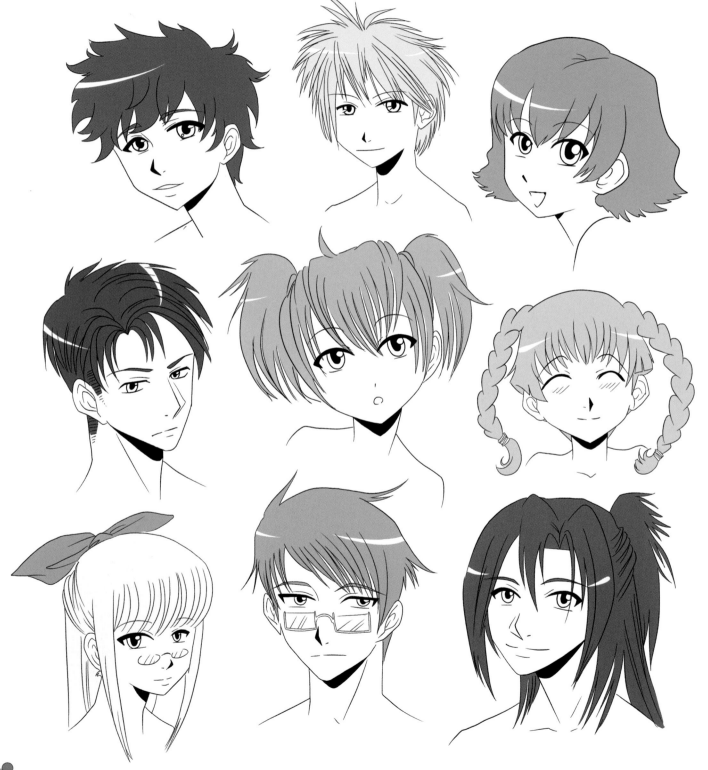

Female Hair

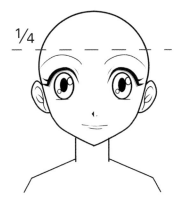

1 The edge of the hair line is in the upper quarter of the face.

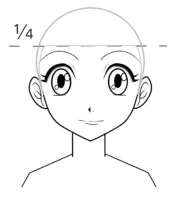

2 Sideburns always fall between the ear and the eye.

MATERIALS

paper

pencil or pen

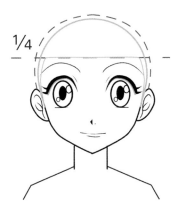

3 Always start the hair from the dotted line above the head. Hair needs volume!

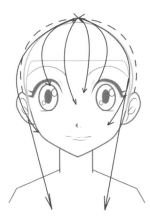

4 For girly hair with bangs, start the shape from a single spot at the top center of the hair line.

5 Draw arrows down from the dot to decide how long the hair will be.

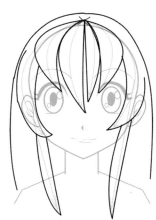

6 Turn those arrows into strands of hair.

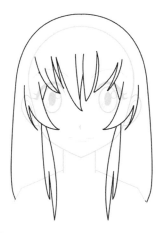

7 Make the hair strands pointy and add a few smaller strands.

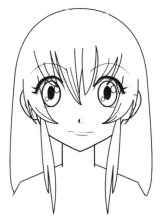

8 For extra effect, add a few lines at the end of each pointed strand.

Male Hair

MATERIALS

paper

pencil or pen

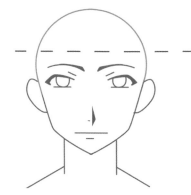

1 The edge of the hairline is in the upper quarter of the face.

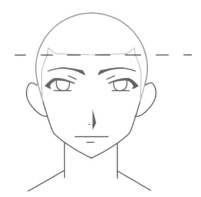

2 Sideburns always fall between the ear and the eye.

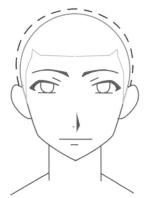

3 Always start the hair from the dotted line above the head line. Hair needs volume.

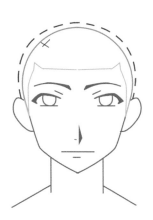

4 To make manga hair for a boy or man, start from a single spot on the side of the head instead of the top.

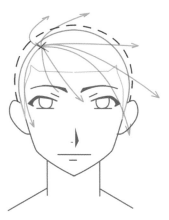

5 Draw arrows out from the dot to decide how long the hair will be.

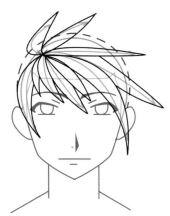

6 Turn the arrows into strands of hair.

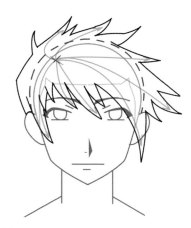

7 Make the strands pointy and add a few smaller strands.

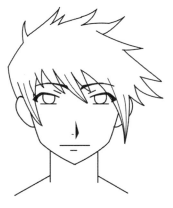

8 For extra effect, add a few lines on the end of each strand.

CLOTHING BASICS

Clothes are an important part of your manga characters. Clothes work with facial expressions to give the characters unique personalities. Always draw the body first, then draw clothes over it.

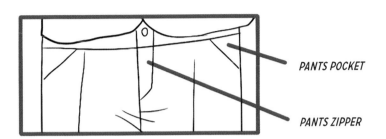

MAIN SEAM

PANTS POCKET

PANTS ZIPPER

Don't forget details like the main seams and buttons.

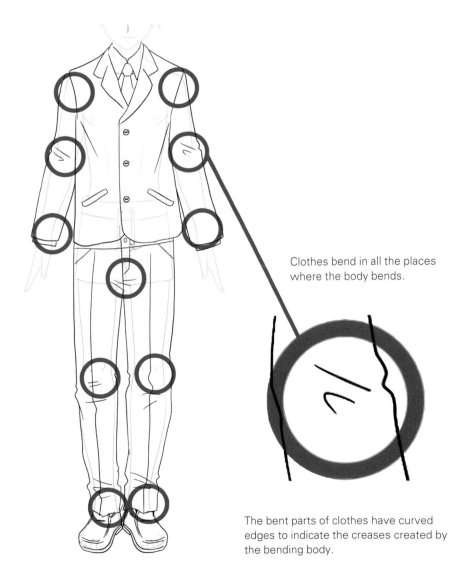

Clothes bend in all the places where the body bends.

The bent parts of clothes have curved edges to indicate the creases created by the bending body.

VISIT **IMPACT-BOOKS.COM/MANGA-CRASH-COURSE** FOR BONUS CONTENT.

67

TYPES OF CLOTHES

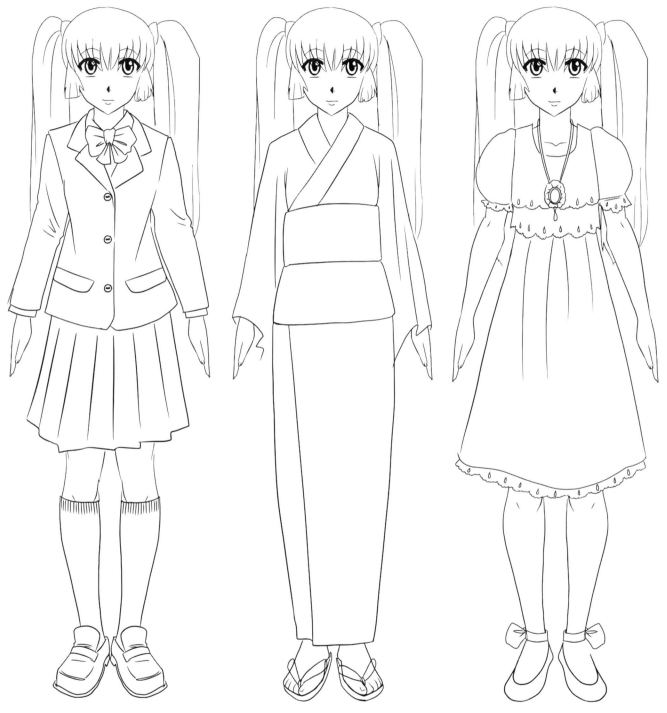

The school uniform is the most common type of clothing in manga. A pleated skirt is easy to draw. Indicate the pleats by drawing parallel lines.

A *yukata* is a traditional Japanese outfit meant for summer wear and is usually worn at festivals. It is worn left side over right with almost no waist line showing.

Casual clothes for girls are usually cute dresses and outfits with puffy sleeves and lots of lace.

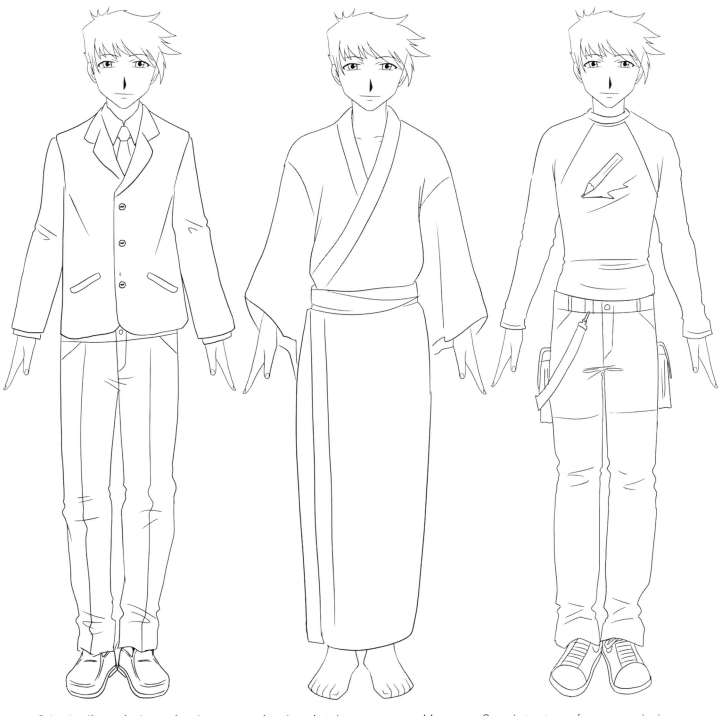

School uniforms for boys often have a tie, jacket and pants.

A male *yukata* has a narrower *obi*, or belt. Boys can even go barefoot in it.

Casual streetwear for guys can be baggy pants and a printed shirt.

DRAWING CLOTHES ON THE FIGURE

When the body moves, the clothes move too. This is shown by drawing creases in the clothes where body parts bend.

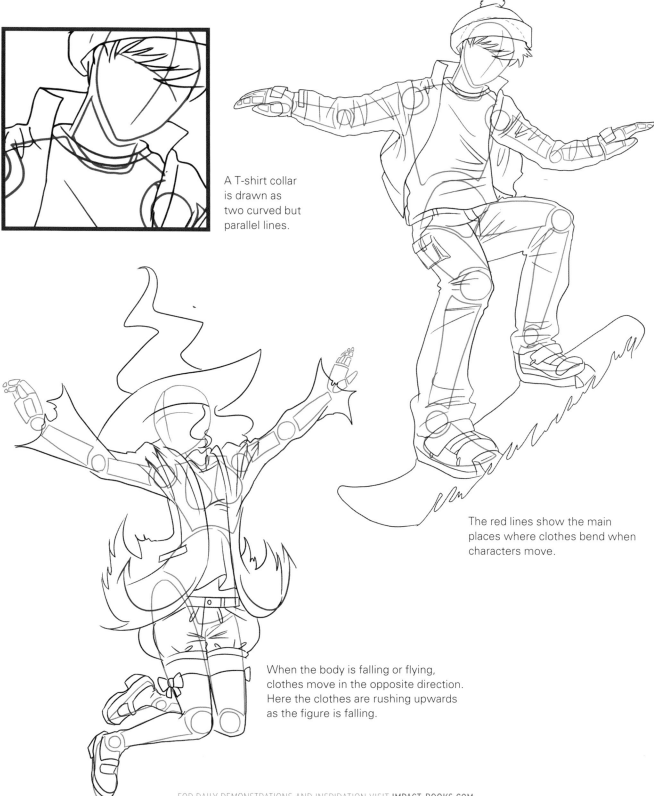

A T-shirt collar is drawn as two curved but parallel lines.

The red lines show the main places where clothes bend when characters move.

When the body is falling or flying, clothes move in the opposite direction. Here the clothes are rushing upwards as the figure is falling.

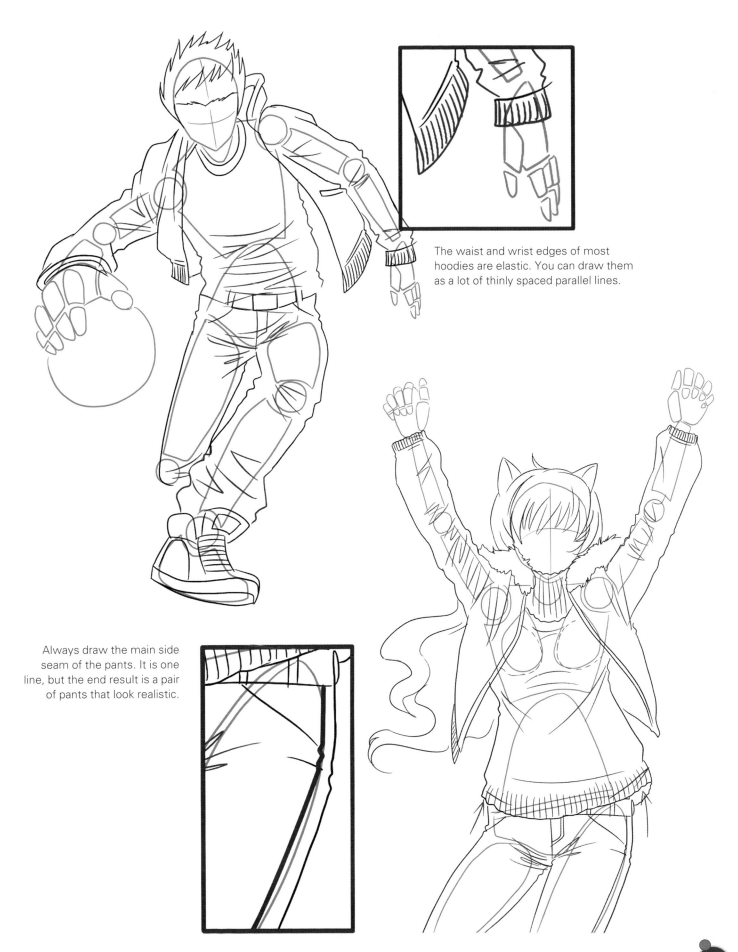

The waist and wrist edges of most hoodies are elastic. You can draw them as a lot of thinly spaced parallel lines.

Always draw the main side seam of the pants. It is one line, but the end result is a pair of pants that look realistic.

VISIT IMPACT-BOOKS.COM/MANGA-CRASH-COURSE FOR BONUS CONTENT.

71

HANDS AND FEET

Hands and feet are most artists' biggest fear, no matter how experienced they are. But don't worry, you will learn two simple patterns to help you draw them.

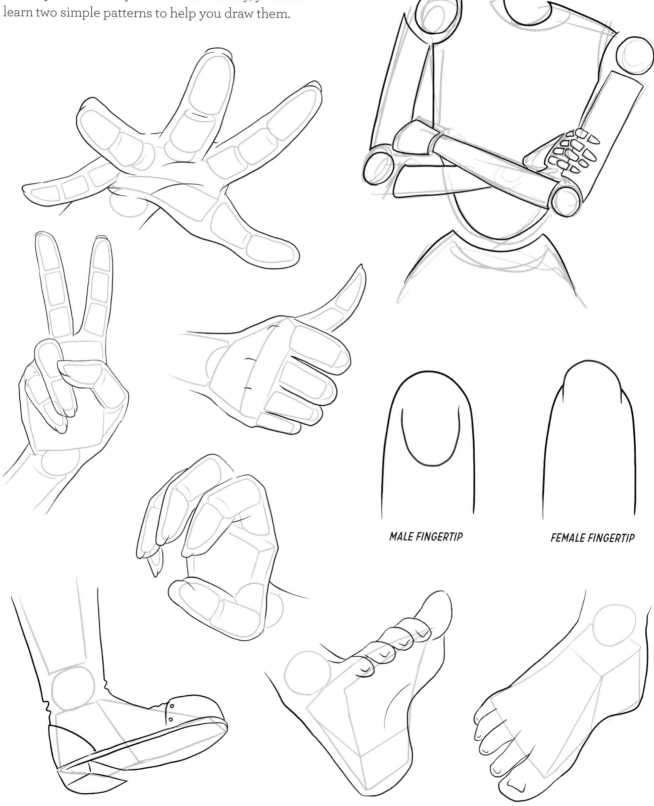

MALE FINGERTIP

FEMALE FINGERTIP

Hands

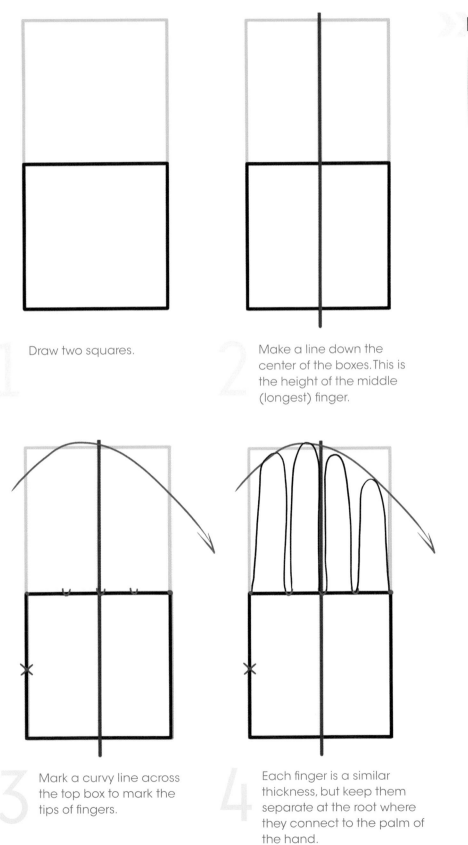

>> **MATERIALS**

eraser

paper

pencil or pen

1 Draw two squares.

2 Make a line down the center of the boxes. This is the height of the middle (longest) finger.

3 Mark a curvy line across the top box to mark the tips of fingers.

4 Each finger is a similar thickness, but keep them separate at the root where they connect to the palm of the hand.

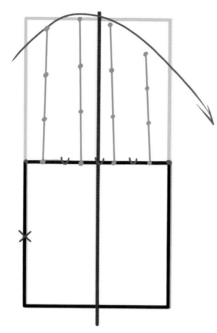

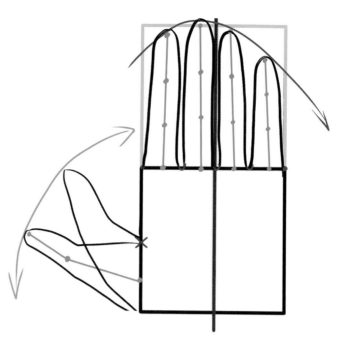

5 Every finger, except the thumb, has three evenly spaced segments. This creates the joints where the fingers bend.

6 The thumb is on the side of the bottom square. It begins in the middle and extends upward and out then back down to the bottom of the box.

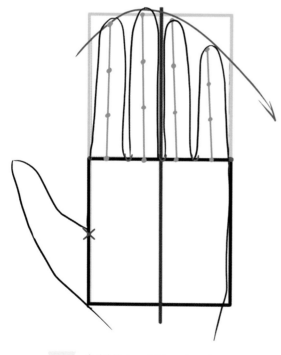

7 Add the wrist by drawing curved lines at the bottom of the box and it's done!

Just One Line

You need only one line extending from the top thumbline to define the palm.

Feet

>> MATERIALS

eraser

paper

pencil or pen

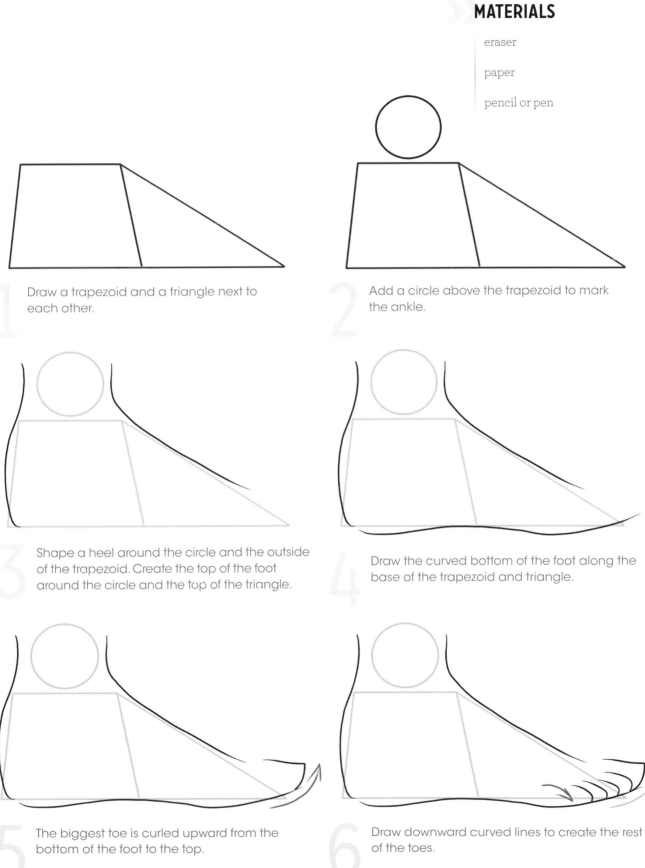

1. Draw a trapezoid and a triangle next to each other.

2. Add a circle above the trapezoid to mark the ankle.

3. Shape a heel around the circle and the outside of the trapezoid. Create the top of the foot around the circle and the top of the triangle.

4. Draw the curved bottom of the foot along the base of the trapezoid and triangle.

5. The biggest toe is curled upward from the bottom of the foot to the top.

6. Draw downward curved lines to create the rest of the toes.

EMOTIONS

Emotions, next to a good story, are the most important element of manga drawing. Drawing expressions makes your characters look alive.

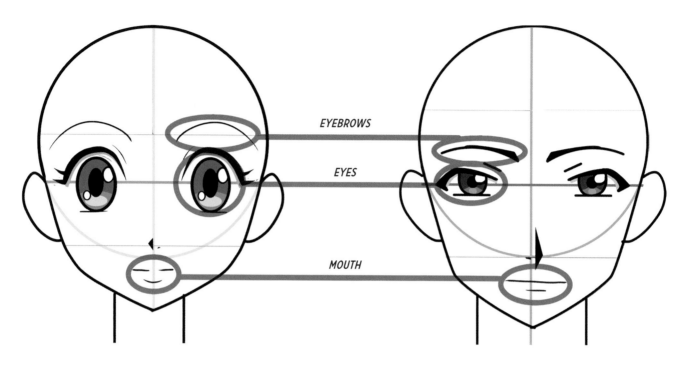

To switch a normal face to an expressive face, just change the eyebrows, eyes and mouth. The rest of the head stays the same. When we move the eyebrows up or down, close the eyes and open the mouth, we get the images below.

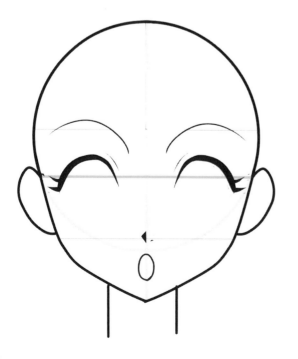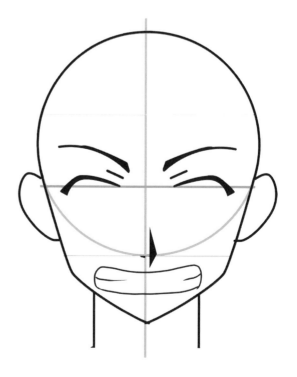

MOST COMMON EMOTIONS

The most intense emotions are happiness, sadness and anger. There are easy tricks for drawing each of these.

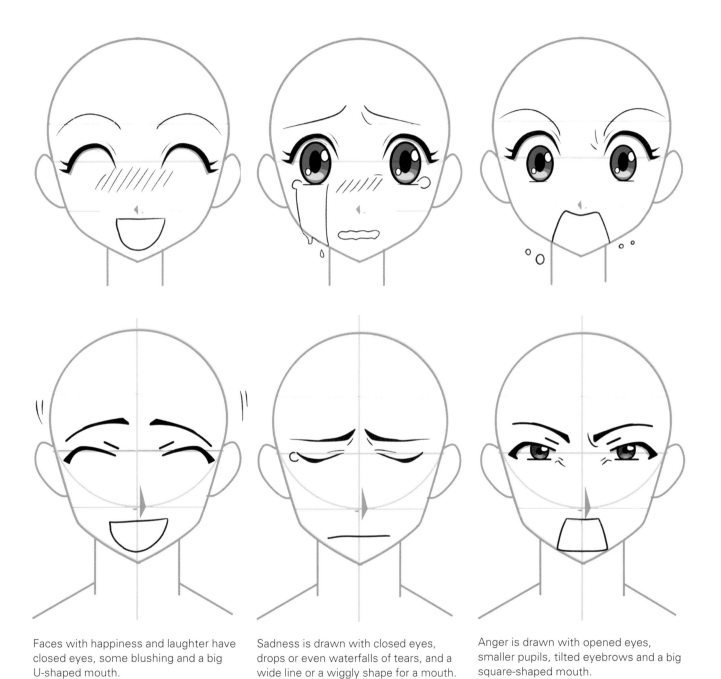

Faces with happiness and laughter have closed eyes, some blushing and a big U-shaped mouth.

Sadness is drawn with closed eyes, drops or even waterfalls of tears, and a wide line or a wiggly shape for a mouth.

Anger is drawn with opened eyes, smaller pupils, tilted eyebrows and a big square-shaped mouth.

VISIT **IMPACT-BOOKS.COM/MANGA-CRASH-COURSE** FOR BONUS CONTENT.

77

ACCESSORIES

These are some of the most common accessories in manga. There are a lot of traditional Japanese items like fans (even metal ones for battle), a *katana* sword, and a lot of modern items we use every day.

Reference Photos Can Help

Use photos as a reference to draw items as realistically as possible.

Manga characters show their personality through their accessories and what they use in daily life or fighting.

Happy characters listen to music, curious ones carry a camera, and fashionable ones wear key chains, pretty bags and shoes.

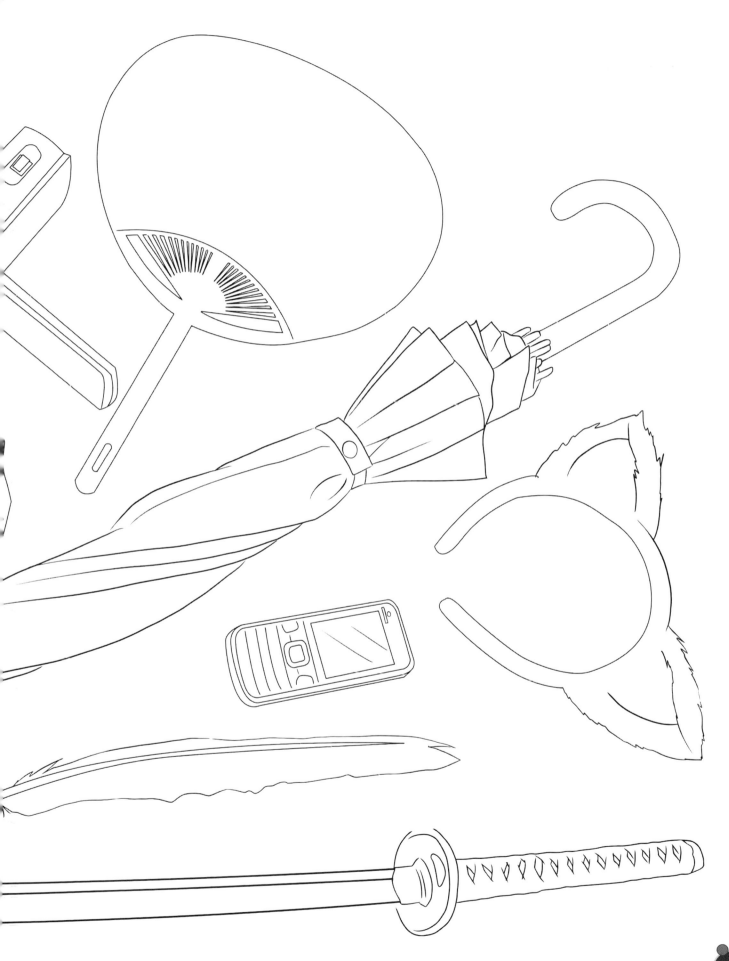

VISIT IMPACT-BOOKS.COM/MANGA-CRASH-COURSE FOR BONUS CONTENT.

79

MANGA SHADING AND INKING TECHNIQUES

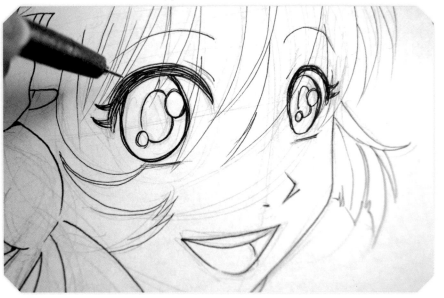

Manga pages and drawings need to have solid black parts. The black areas are filled with ink or fine liner pens.

Before adding ink, you first must sketch out your idea.

After you're finished with your sketch, add the ink. Fine liner pens are a great tool for beginners.

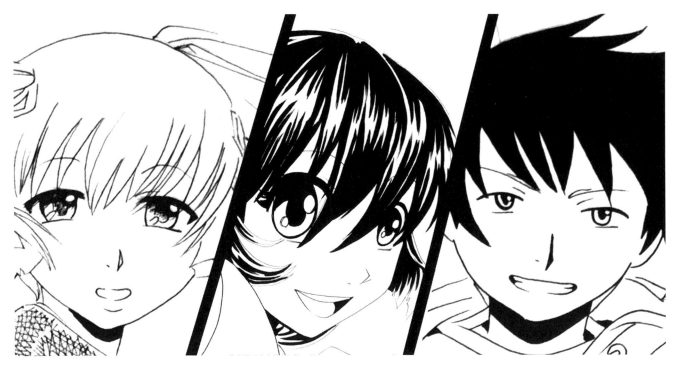

Depending on the thickness of the lines you make and how you shade, your manga drawings can look different every time.

Beta Shading

Beta is a type of shading for shōnen manga, which is manga with lots of action and magic themes and feature mostly male characters. Beta uses fully black spaces to cover only those items that would be the darkest colors naturally (dark hair, a dark shirt, a shadow). Black shadows can be used and minimal gray areas can be created using crosshatching or other textures made of drawn lines.

MATERIALS

eraser

fine liner pen

paper

pencil

permanent black ink

small paintbrush

1 Use a thick fine liner pen to ink shadows. Always shade a big black shape under the chin. This shadow provides depth to the neck so the face pops out.

2 Details on the clothes are minimal.

3 Every darker color on your character is painted black using a small paintbrush and permanent black ink. For example, brown hair would be inked black.

4 Except for the dark colors and the chin shadow, the only other shadows added are tiny triangles in some of the creases in the clothes.

VISIT IMPACT-BOOKS.COM/MANGA-CRASH-COURSE FOR BONUS CONTENT.

81

Tsuya Beta Shading

Tsuya beta is a type of shading for shōjo manga, which is manga with romance and fantasy themes. Shading and inking with tsuya beta is more delicate than beta shading.

MATERIALS

eraser

fine liner pen

paper

pencil

permanent black ink

small paintbrush

1 Use a thin fine liner to draw the lines over the pencil.

2 Carefully ink every little detail in your drawing.

3 After you ink the lines, erase the pencil lines so you can start shading the hair.

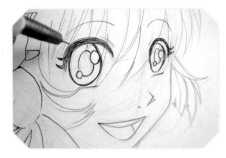

4 For shading you need ink and a small paintbrush. If you plan to add color after shading, make sure your ink is waterproof.

5 Mark where the shiniest part of the hair will be by sketching two curvy lines across the bangs with a pencil.

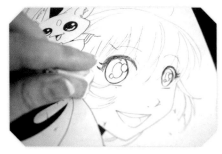

6 For each strand of hair, start your brushstrokes from the ends and flick them towards the middle. Don't worry about crossing the curved guidelines, just try not to connect the upper lines with the lower lines.

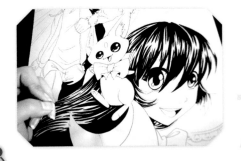

7 Continue doing this for every strand and you'll have tsuya beta shaded hair.

Crosshatching

Crosshatching is another technique for shading in manga. You can use it for backgrounds, textures, emotions and more. There are lots of different types of shading, but crosshatching is the simplest type.

MATERIALS

paper

fine liner pen

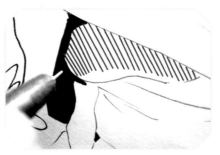

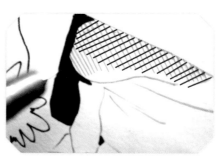

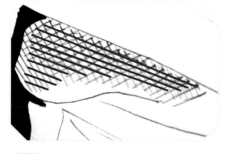

We will use crosshatching to make this sweater texture.

1 Draw a lot of closely spaced parallel lines.

2 Cross those lines with more parallel lines.

3 Add a third layer of parallel lines in another direction.

4 Add a fourth layer of parallel lines to create a darker shade.

Lights and Darks

You can crosshatch a surface with only one layer of parallel lines to get the lightest shade, or you can use more layers, up to four of them, to get the darkest crosshatching shade.

Making and Using Traditional Gradients

One way to get a manga gradient is by using screentone sheets. Screentone is a blank adhesive sheet of foil that is used in manga for special textures and shading. You can print the foil with your desired halftone pattern or texture, and then the foil is placed on an area to be shaded and adhered to your drawing. This is an ingenious type of shading tool that is used almost exclusively in manga. Screentones can be layered together for more levels of shading or used for clothing textures. You can even print out buildings and backgrounds on the foil, and stick it behind your characters in manga panels.

MATERIALS

blank screentone sheets

black-and-white printer

computer

ruler for pressing

scrap paper

single-edged razor blade

1 Screentone is bought as a set of blank foils.

2 You can choose and download patterns from the Internet.

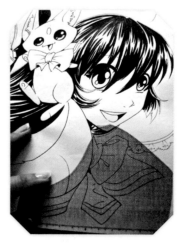

3 Print your chosen patterns onto the foil.

4 Cut out enough foil to cover a surface you want and gently press it on the paper.

5 Use a single-edged razor blade to cut away the foil from areas you don't want shaded. The foil can be removed easily for repositioning.

6 Place the extra cut-out pieces back on the foil base for use on smaller details.

7 Use a single-edged razor blade to scratch out areas you want to be white.

8 Place a piece of scrap paper over the foiled area. Use a ruler to press the screentone completely down to adhere it securely.

AND DONE!

VISIT **IMPACT-BOOKS.COM/MANGA-CRASH-COURSE** FOR BONUS CONTENT.

85

4

PUTTING IT
Together

Now that you have learned all the basics, you are prepared to put them to use. You can now create your own complete characters and stories. The only thing left is to improve even more. In this chapter I will give you a few ideas to start your manga adventure! As a bonus, if you ever lack an idea, there is a cool game that will help you!

The Idea Game

A lot of times we need an idea for a drawing, and the best way to get an idea is to experiment. It's good to draw themes that you wouldn't usually think of right away.

MATERIALS

dice

paper

pencil or pen

NEED AN IDEA?

I HAVE A GAME!

1 Draw a list like the one below. You can even add more columns, like pets, background or hair color. If you have a six-sided die, make a chart with six rows.

These are just examples. Use this chart to make your own original combinations, too.

PERSONALITY (most common types of characters, how they act, what they like, how they were raised, etc.)	*OCCUPATION* (different kinds of work characters do, or what world they come from)	*MAGIC/ABILITY* (manga characters usually have special abilities or powers, amulets, elements, etc.)
1. Sloppy	1. School Girl	1. Android
2. Happy	2. Space Pilot	2. Vampire
3. Scary	3. Maid	3. Sword Master
4. Shy	4. Samurai	4. Shape-Shifter
5. Noisy	5. Knight	5. Winged
6. Know-It-All	6. Athlete	6. Fire Powers

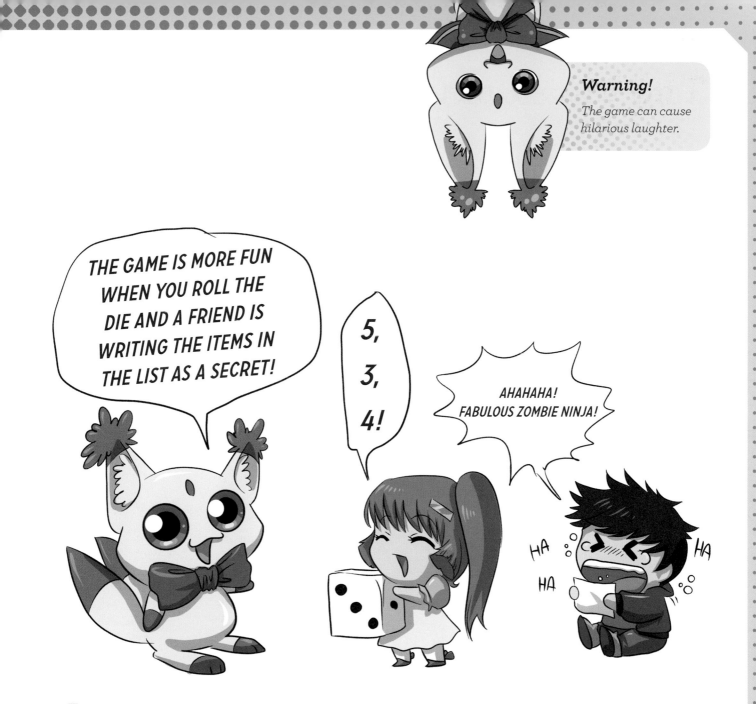

Warning!

The game can cause hilarious laughter.

THE GAME IS MORE FUN WHEN YOU ROLL THE DIE AND A FRIEND IS WRITING THE ITEMS IN THE LIST AS A SECRET!

5, 3, 4!

AHAHAHA! FABULOUS ZOMBIE NINJA!

HA HA HA HA

2 Roll the dice! Rolling the dice turns all our listed characteristics into a random jumble!

 Example: If you rolled a 3, then 1, then 2, you get a: "Scary School Girl Vampire." That sounds fun—let's draw her!

Let's make more:

— 6, 2, 1 makes a "Know-It-All Space Pilot Android."
— 2, 3, 4 makes a "Happy Shape-Shifter Maid."
— 4, 4, 3 makes a "Shy Samurai Sword Master."
— 5, 5, 5 makes a "Noisy Winged Knight."
— 1, 6, 6 makes a "Sloppy Fire-Powered Athlete."

VISIT **IMPACT-BOOKS.COM/MANGA-CRASH-COURSE** FOR BONUS CONTENT.

89

Scary School Girl Vampire

Let's make a fun character and matching chibi from our first idea-game dice roll! We can make her scary and pretty at the same time. With a pretty school uniform and some dark colors mixed with red, a vampire's favorite, our scary school girl might not be truly scary as a person, but that will be the first impression of her.

» MATERIALS

coloring tools of your choice

eraser

paper

pen

pencil

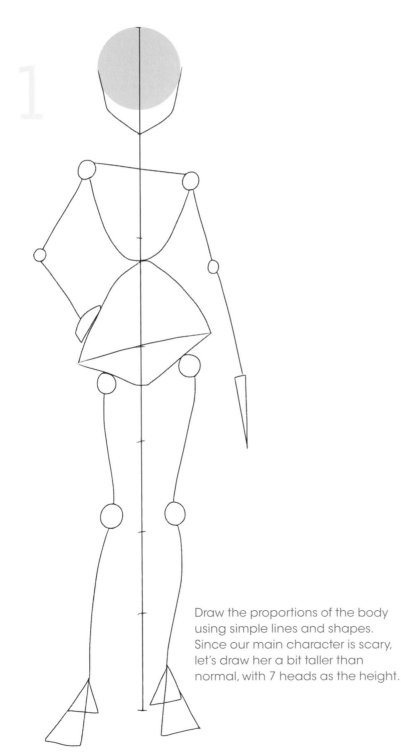

Draw the proportions of the body using simple lines and shapes. Since our main character is scary, let's draw her a bit taller than normal, with 7 heads as the height.

Chibi characters are usually 2 heads tall.

2

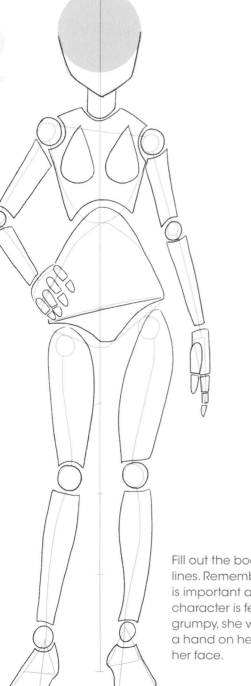

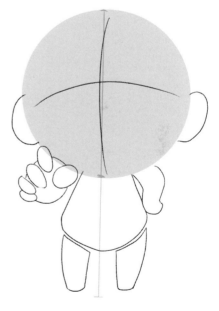

Fill out the body around the basic lines. Remember, body language is important and can show what a character is feeling. If someone is grumpy, she will tend to stand with a hand on her hip and a frown on her face.

The chibi character will point at us, with evil laughter, so we enlarge its hand, and form fingers like small ovals.

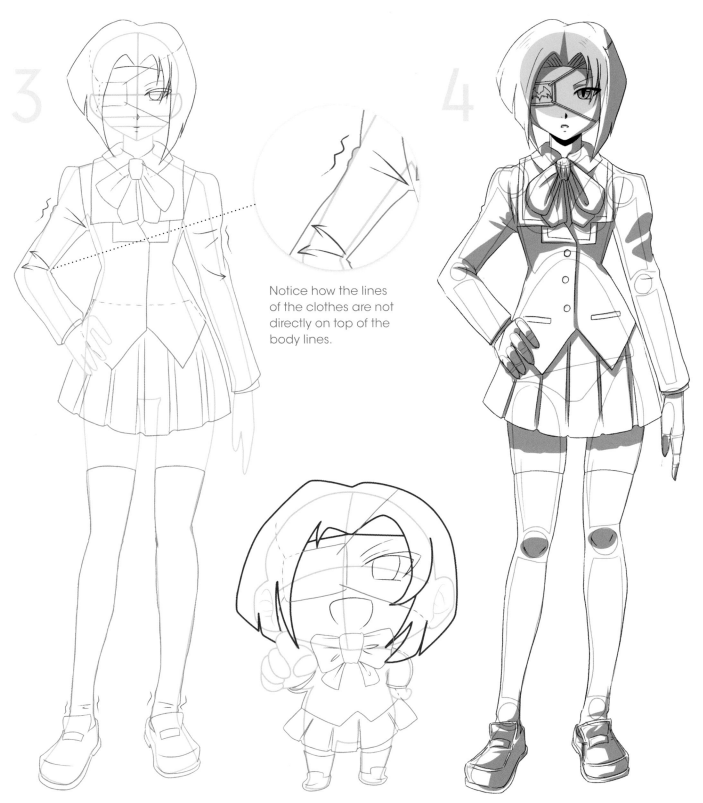

Notice how the lines of the clothes are not directly on top of the body lines.

Draw the character's outfit over the basic body shape and erase the extra lines. The red lines show you where the details and folds should be drawn on the clothes.

The lines for the edge of the hair are always drawn away from the head shape to add volume.

Here you can see the basic shading on this type of character: the most important shadow under the chin, then under the chest, the skirt and the knees.

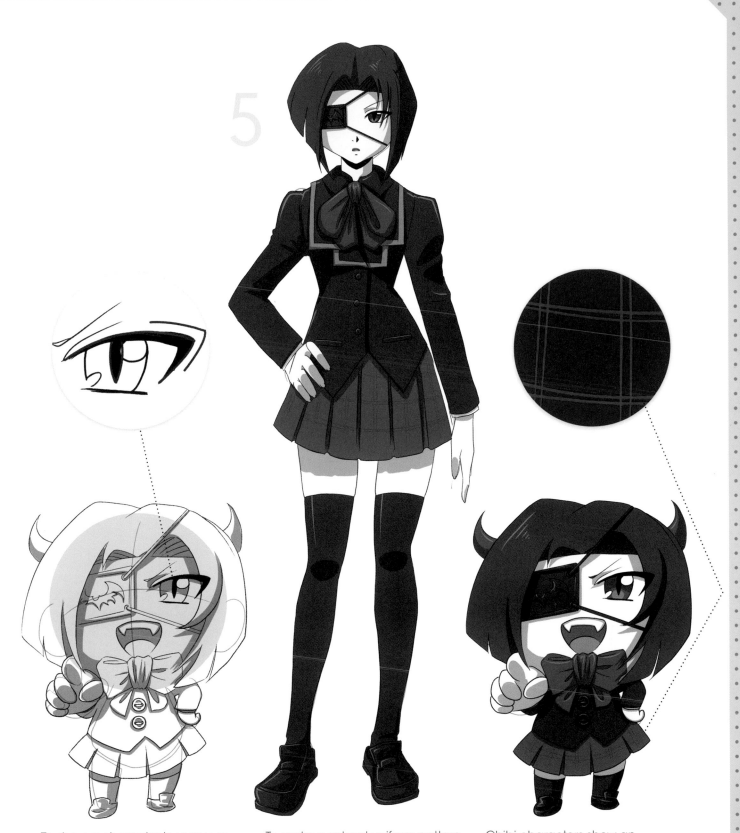

5

To show a character is scary, we can give them pointy eyes and a pointy pupil, like a cat's eye.

To make a school uniform pattern on the skirt, cross two parallel lines with another set of two parallel lines to create a grid.

Chibi characters show an exaggerated personality, so add some horns to make her look a bit more evil with fangs showing.

VISIT **IMPACT-BOOKS.COM/MANGA-CRASH-COURSE** FOR BONUS CONTENT.

93

Know-It-All Space Pilot Android

Now isn't this a long title to have? This character is smart so she is always hooked up to her Internet tablet in her palm, and we can add glasses to her design, just as a symbol of her intelligence. She can be brightly colored as a person with bright green hair and unusual glowing orange eyes.

MATERIALS

coloring tools of your choice

eraser

paper

pen

pencil

white paint or white pen

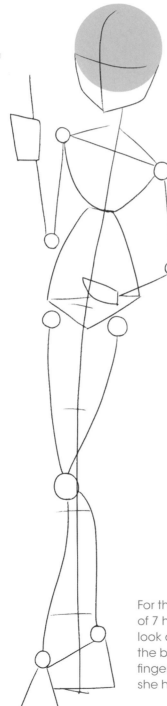

1

For the main character use the height of 7 heads so that our know-it-all can look a bit older and wiser. As you plan the basic lines and shapes, add a finger high in the air to notify us that she has a smart thing to say.

Begin drawing the matching chibi character at the typical height of 2 heads tall.

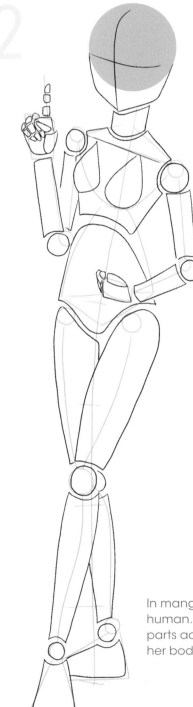

In manga androids usually look human. With a few metal or robotic parts added later, we can still draw her body shape normally.

Fill out the chibi with cute, rounded shapes. We will give this character a digital tablet to proudly show when speaking. That is why the chibi has a raised arm.

VISIT **IMPACT-BOOKS.COM/MANGA-CRASH-COURSE** FOR BONUS CONTENT.

95

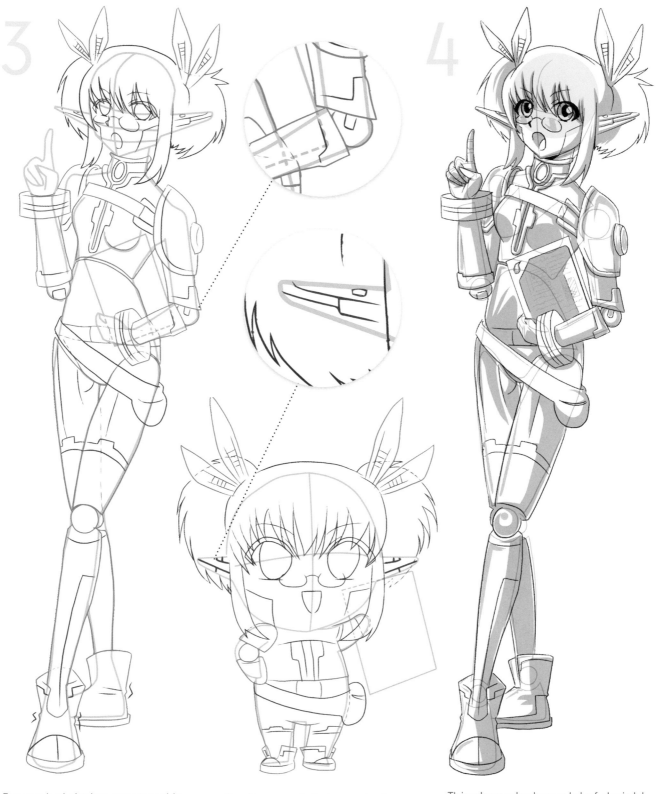

For a robot design, you need to draw some body parts as circles and machine parts.

Tiny lines and circles make for great details on robots.

This character has a lot of straight lines on her body where the android parts are created. She even has them on her cheeks and in her hair ties.

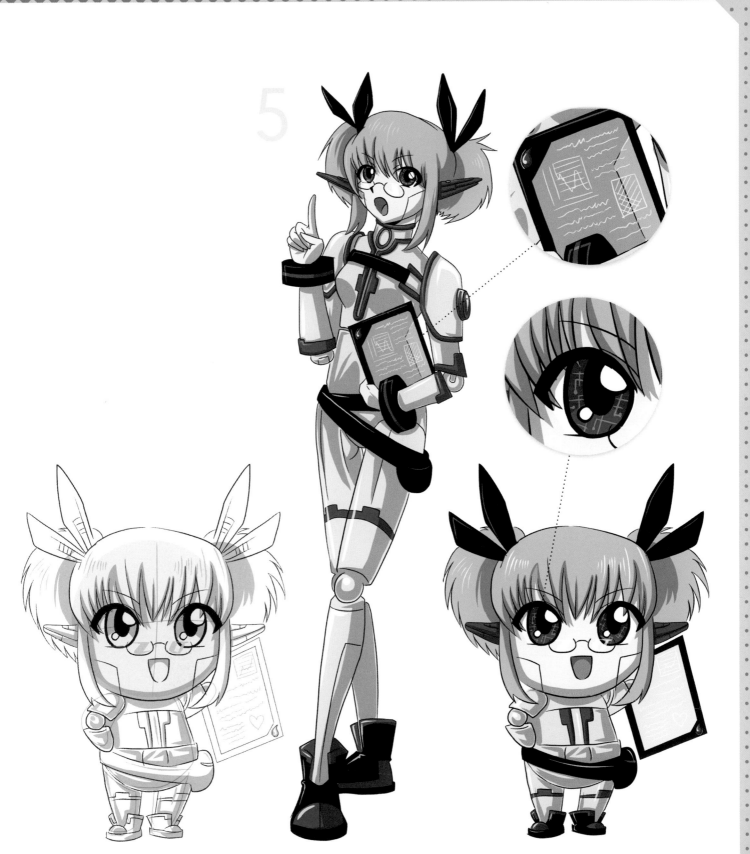

5

Shadows on this character are special because she is covered with metal. Metal shadows point toward the center of the character and almost never touch the outside edges.

Add some high-tech see-through parts like the screen on the tablet. To draw this, just color the parts of the body behind the pad in a lighter shade.

Add some circuit lines inside her eyes with white paint or a white pen.

VISIT **IMPACT-BOOKS.COM/MANGA-CRASH-COURSE** FOR BONUS CONTENT.

97

Happy Shape-Shifter Maid

Shape-shifters are special characters that can turn into animals or mystical creatures. This shape-shifter is a happy, bubbly person, working as a maid. With baby pink hair and round kind eyes, she is a playful, bright character, who only changes her shape just enough to show off her cute cat ears and fluffy tail.

MATERIALS

coloring tools of your choice

eraser

paper

pen

pencil

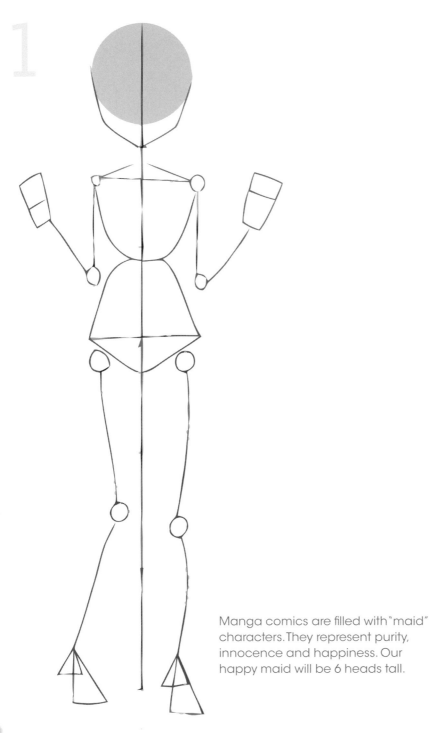

Manga comics are filled with "maid" characters. They represent purity, innocence and happiness. Our happy maid will be 6 heads tall.

Draw the chibi character at the usual 2 heads tall.

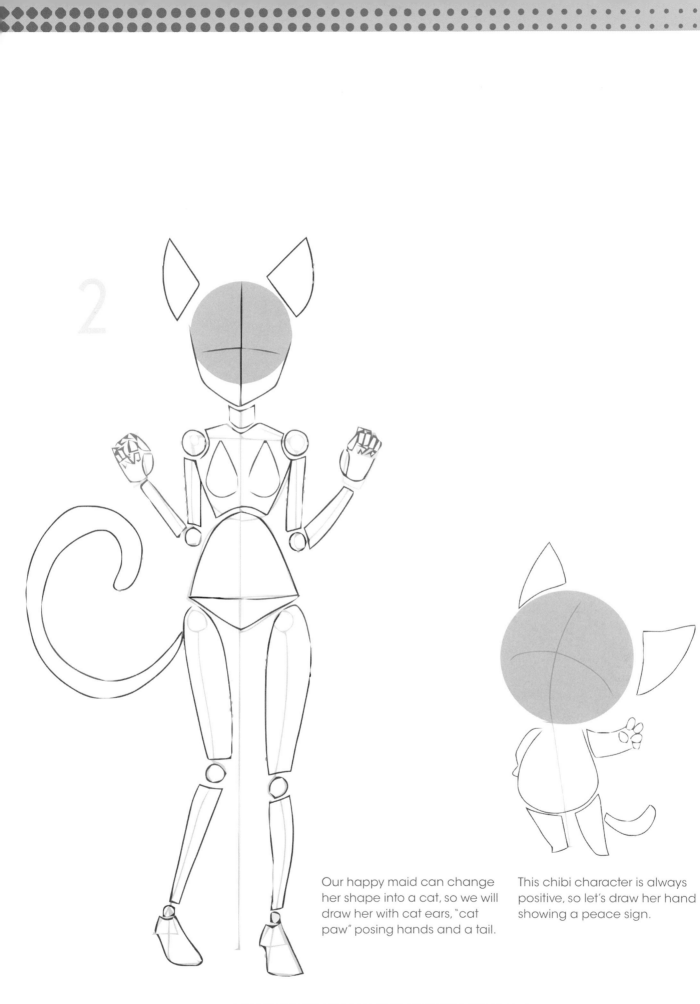

2

Our happy maid can change her shape into a cat, so we will draw her with cat ears, "cat paw" posing hands and a tail.

This chibi character is always positive, so let's draw her hand showing a peace sign.

VISIT **IMPACT-BOOKS.COM/MANGA-CRASH-COURSE** FOR BONUS CONTENT.

99

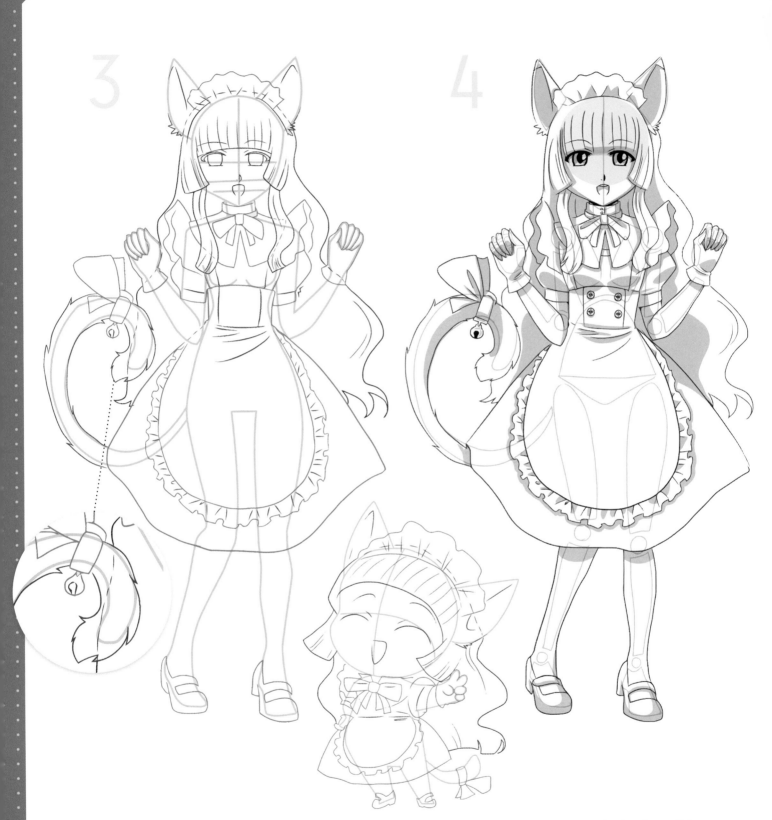

Draw the clothes around the shape of the body. Furry details, such as the tail, always have curvy zigzag edges.

Even when drawing puffy skirts, you need to draw the body inside, to prevent mistakes.

The main areas to shade on this character are under her bangs, in her ears, under her skirt and inside her hair. Maids wear frilly clothes, so the frills are drawn with a wiggly line on one side, and sets of V-shaped lines on the other.

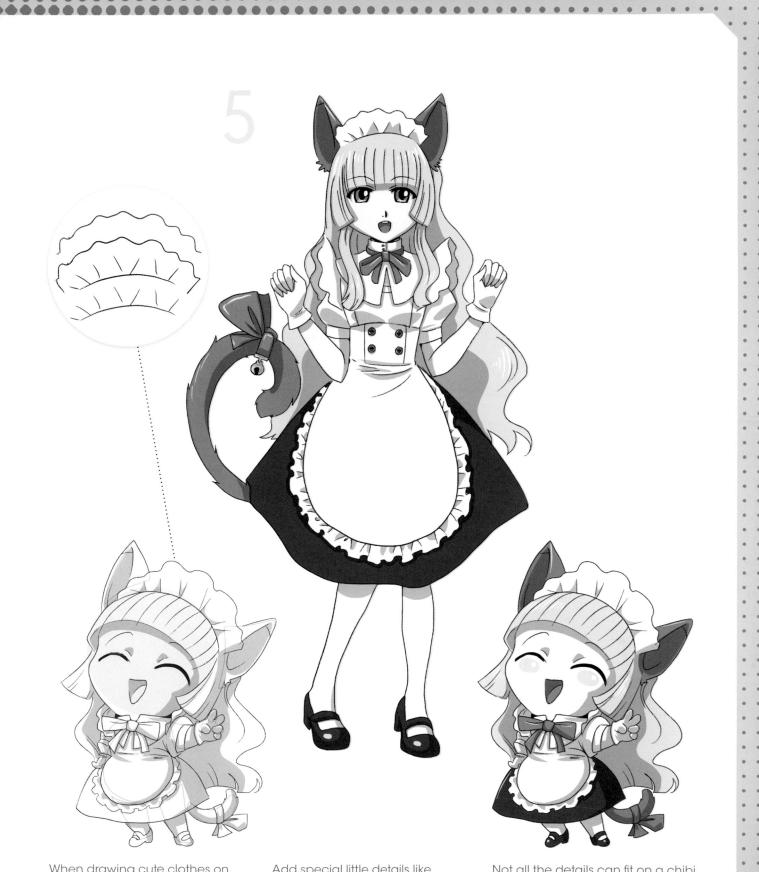

5

When drawing cute clothes on your chibi characters, make all the details bigger than normal, like the bows around her collar and tail.

Add special little details like buttons, bows and a little cat bell on the top of her tail. These details really help change typical manga drawings into unique characters!

Not all the details can fit on a chibi, so choose the details you like the most and draw those.

VISIT IMPACT-BOOKS.COM/MANGA-CRASH-COURSE FOR BONUS CONTENT.

101

Shy Samurai Sword Master

This character is a humble warrior with not many words to share, so you can show his personality through his hair. A pointy, perky hairdo will show that he has warrior skill, and the green color will show that his personality is calm. He wears traditional robes and gets shy and flustered any time a girl asks him something, but that doesn't mean that he isn't good on the battlefield.

MATERIALS

coloring tools of your choice

eraser

paper

pen

pencil

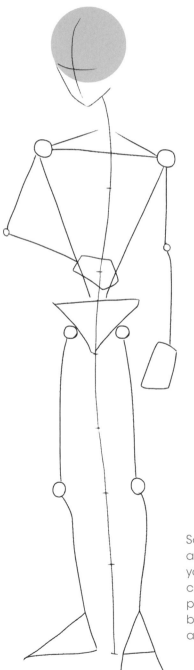

Samurai were fierce warriors, but a warrior who is shy is something you don't see every day in a character. We will draw him in a pose to prepare for battle, and because he's a warrior, draw him an imposing 8 heads tall.

The matching chibi character will still be the usual 2 heads tall.

2

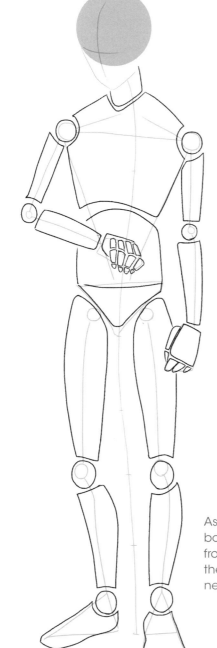

As you fill out the shape of the body, draw one arm across the front of his body. He'll be holding the handle of his sword, right next to his waist.

This chibi character will show us a shy pose, using his little hand to cover his blushing cheek.

VISIT **IMPACT-BOOKS.COM/MANGA-CRASH-COURSE** FOR BONUS CONTENT.

103

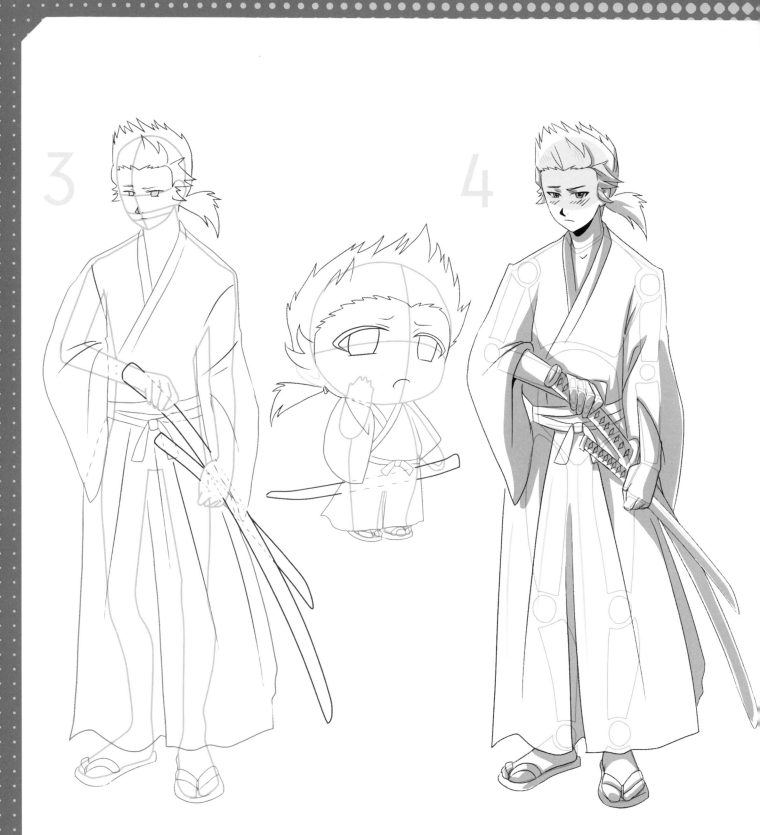

Draw the samurai robe and sword over the body shape. The samurai in manga usually wear this set of clothes: the upper part is called *gi* and the lower part is called *hakama*.

Make sure you draw the correct overlap on the robes and follow the green lines to know where the main folds are.

The main shading on this character is under his chin, under his big sleeves and on the top of his feet. Add an extra sword at his side to emphasize his warrior abilities.

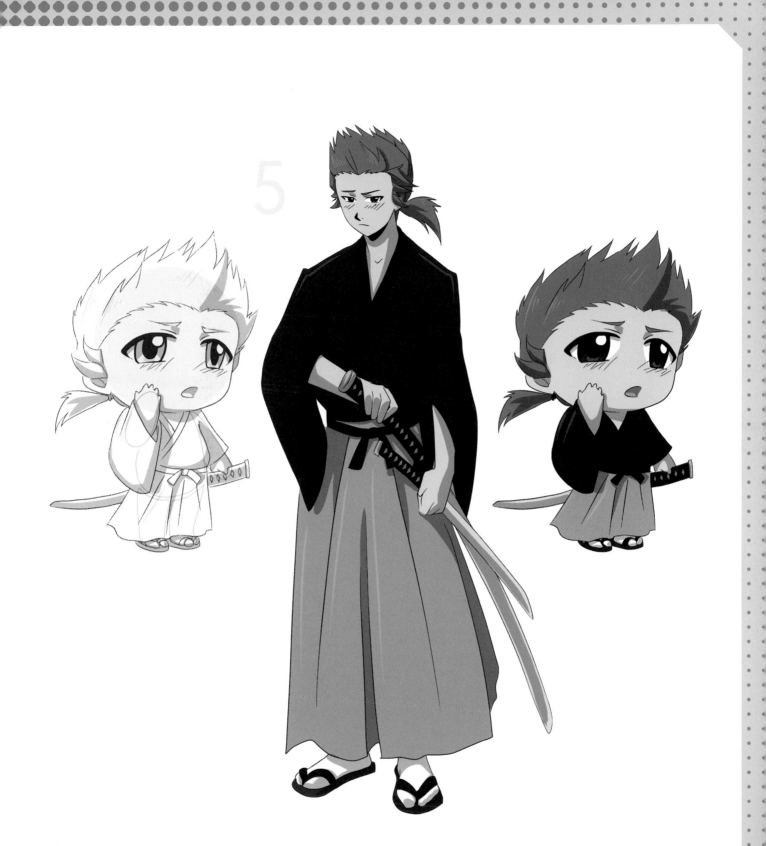

Since the chibi is smaller, only a single smaller sword will fit on his character.

Pay attention when drawing Japanese weapons. A *katana* has a long handle, long enough to be held with two hands. The smaller sword that is next to the katana is called *wakizashi*, and its handle is shorter.

Not all the details can fit on a chibi, so choose the details you like the most.

VISIT **IMPACT-BOOKS.COM/MANGA-CRASH-COURSE** FOR BONUS CONTENT.

105

Noisy Winged Knight

This should be a character of big presence, with wide shoulders and a big smile. He is always ready to impress everyone, to show off his might and strength. He spits all over the place while bragging about his latest victories and achievements, making the ground shake whenever he speaks. This is a strong and funny character, but don't take his word for it!

» MATERIALS

coloring tools of your choice

eraser

paper

pen

pencil

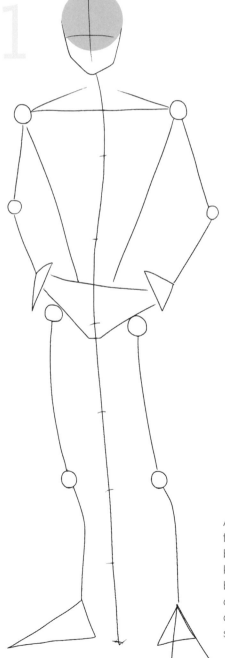

1

A lot of manga stories have a fantasy theme. There are many brave knights and to draw a noisy knight will be easy—just draw a big mouth to make him shout out orders. This guy is 8 heads tall, and to show his big presence, his shoulders are as wide as 3 heads!

We will tilt the middle line to make the chibi stand in a moving pose.

FOR DAILY DEMONSTRATIONS AND INSPIRATION VISIT IMPACT-BOOKS.COM.

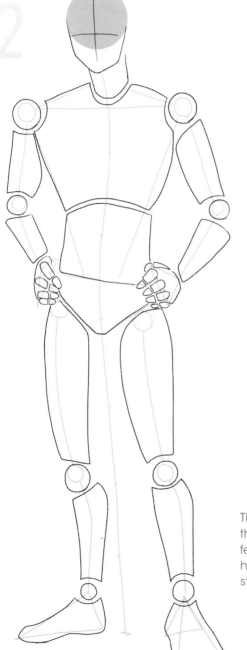

2

This guy is just huge! He has a thick neck, big muscles and big feet and has his hands on his hips to show to everyone how strong he is.

The knight's chibi personality has one fist proudly up in the air, showing off.

VISIT **IMPACT-BOOKS.COM/MANGA-CRASH-COURSE** FOR BONUS CONTENT.

107

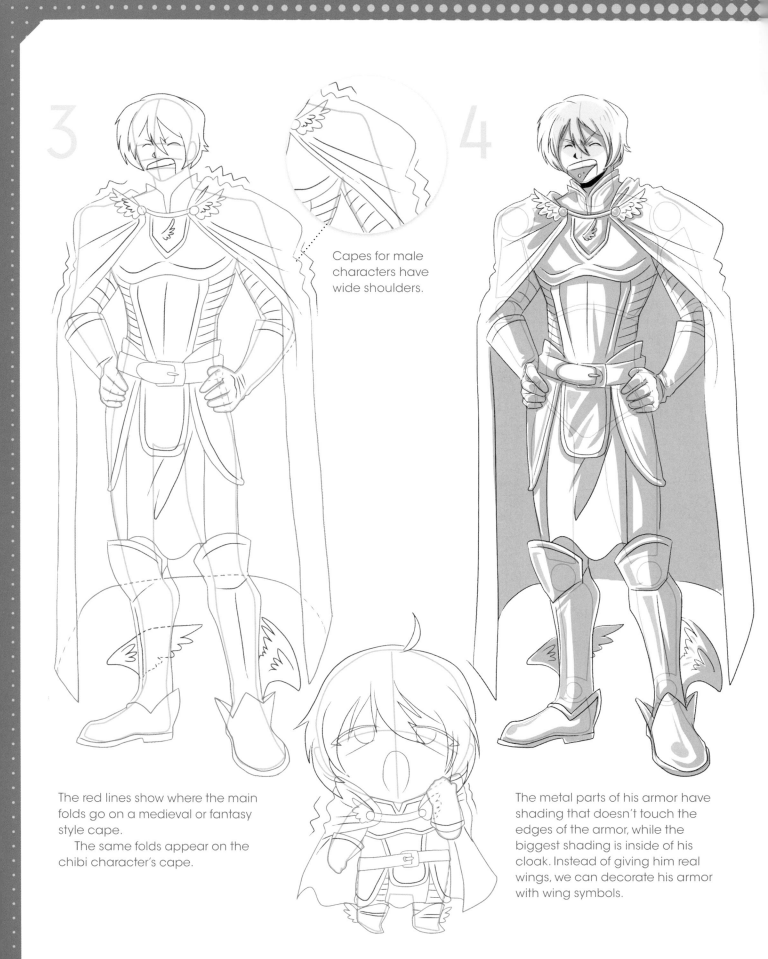

3

Capes for male characters have wide shoulders.

4

The red lines show where the main folds go on a medieval or fantasy style cape.

The same folds appear on the chibi character's cape.

The metal parts of his armor have shading that doesn't touch the edges of the armor, while the biggest shading is inside of his cloak. Instead of giving him real wings, we can decorate his armor with wing symbols.

5

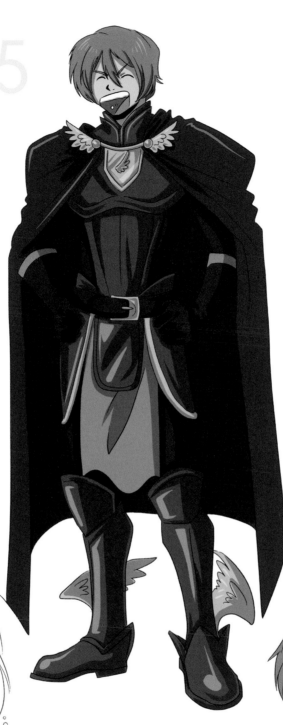

The more details you can fit on chibi characters, the more impressive they look. Notice the belt buckle and the small winged shoes on the chibi knight.

Red is a bold, powerful color for drawing warriors. Try to make the armor as detailed as you can.

VISIT **IMPACT-BOOKS.COM/MANGA-CRASH-COURSE** FOR BONUS CONTENT.

109

Sloppy Fire-Powered Athlete

This character needs to have a lot of fire-red details and a personality that might not be appealing to everyone. Sometimes heroes like these forget to wear clean uniforms, or take a bath, or simply look at what their powers did to their clothes. These fiery types are not strangers to picking fights, making messes and destroying things, but that's what makes them so fun and exciting to watch in manga.

》 MATERIALS

coloring tools of your choice

eraser

paper

pen

pencil

1

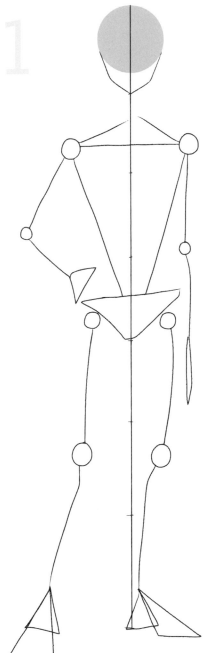

Manga often have a fire-powered character who is usually a hero and stands proud. Even though he's a hero, he's not imposing like the knight or samuri, so draw him at a standard height of 7 heads high.

The chibi will be 2 heads tall.

2

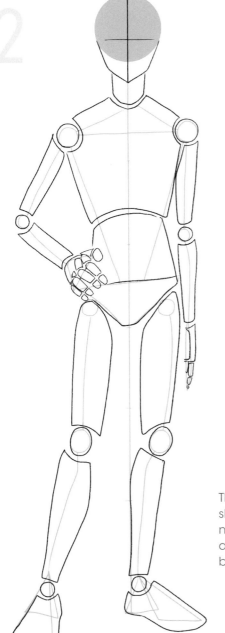

The fire-powered athlete has a slender body, with muscles that are not too big. Let's make this athlete a basketball player and show that by drawing bigger feet.

His chibi personality will rush towards us, arm outstretched with an enchanted fireball.

VISIT IMPACT-BOOKS.COM/MANGA-CRASH-COURSE FOR BONUS CONTENT.

111

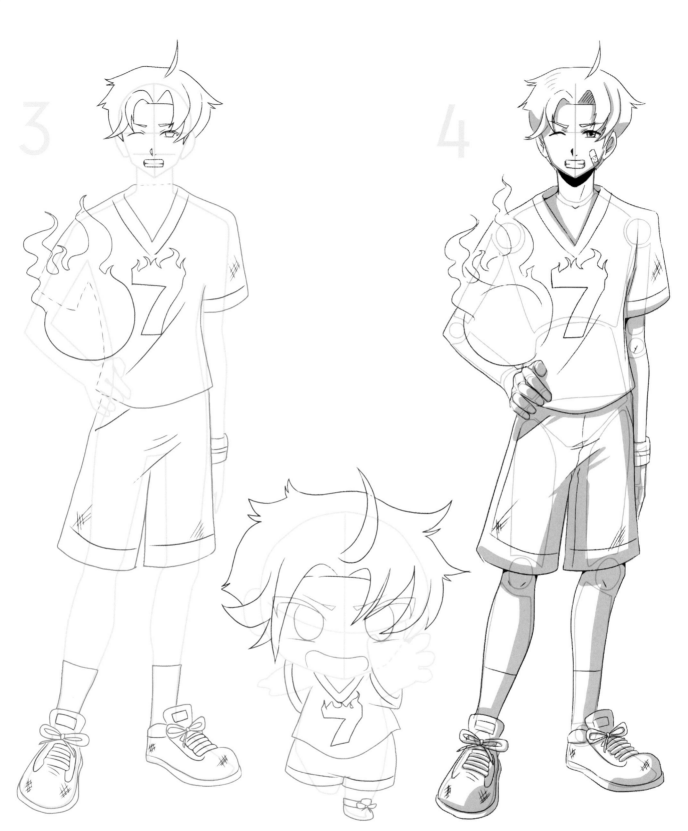

When drawing things in front of a character, such as this fiery sports ball, everything behind it is invisible including the athlete's arm and shirt.

But that doesn't mean those features aren't there. Make sure to draw everything together, then draw the foreground details in ink.

Since our athlete is a sloppy character, he leaves his clothes dirty and charred from his fire powers. To draw charred or messy clothes, just draw random crossed lines similar to crosshatching on the edges of his skin, gear or clothes.

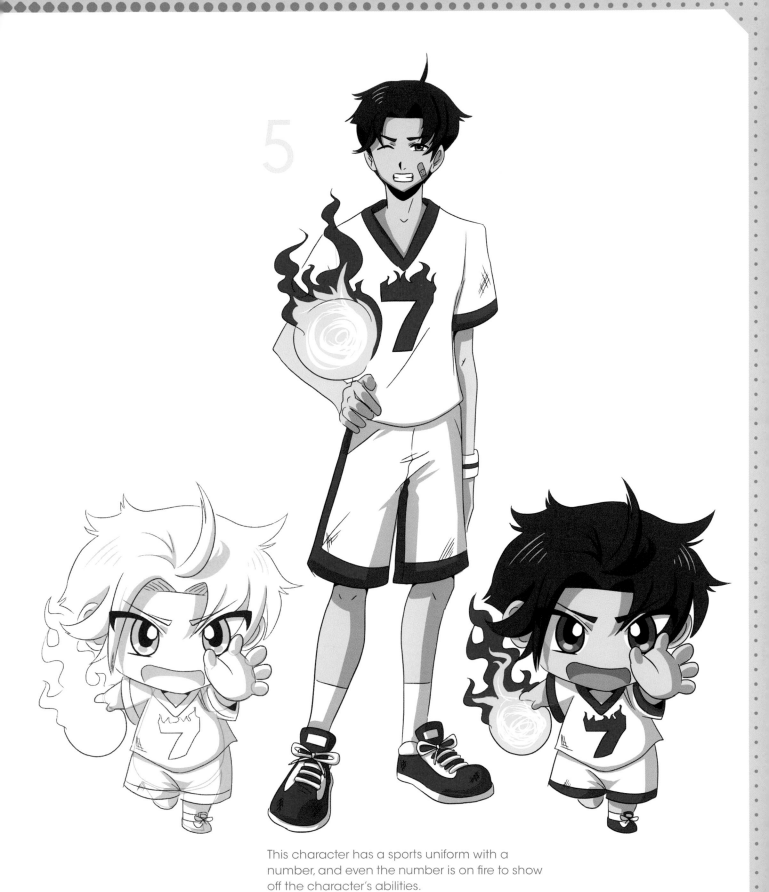

This character has a sports uniform with a number, and even the number is on fire to show off the character's abilities.

When drawing fire objects or magic, remember that the core should be bright or even white, the middle is orange or yellow, and the edges are colored red.

Draw Characters Together

When you draw characters together, there are a few tricks and tips to make a whole picture look even more exciting.

MATERIALS

art paper

eraser

fine liner or ink an ink pen

pencil

permanent black marker

scrap paper

small paintbrush

tissues

watercolors

1 On a piece of scrap paper, draw out a sketch of the characters and scene. Don't worry too much about details at this point.

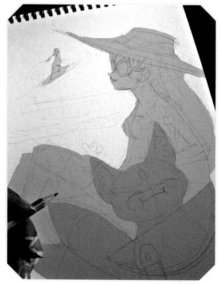

2 Split the sketch into nine parts. The four main dots are the places to put the most important details, in this case, the surfer in the back, Maya's face, her knee, and Mimi's face. Adjust your sketch as needed.

3 Redraw the revised sketch on art paper. Try to include three objects or people at different distances: one closest to the eye (Mimi) is the largest, one a bit farther (Maya) is smaller, and a background image (Marco on the waves) is the smallest of all.

4 In this drawing try your best to work on even the smallest details.

5 Outline the characters with a pen. Make sure to pick a water-resistant fine liner. Left: water-resistant lines; right: water-soluble lines.

6 Add tiny crosshatched textures to create detail.

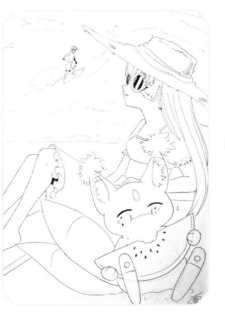

7 Press the fine liner harder to create thicker lines for the closer characters, like Mimi.

8 Do your best to make the lines smooth—it's the secret of the manga style. It is the toughest thing to master and takes the longest to learn, but practice makes perfect!

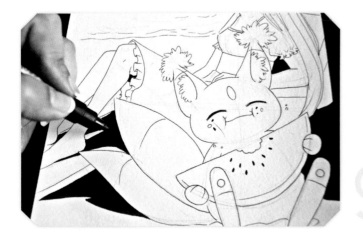

9 Color in a lot of the background areas with a permanent marker (at least a third of the drawing) to make your subjects pop out from the page.

10 After you have outlined the drawing with a black pen, add color. Never apply raw color to the work. Always test the color on a piece of paper before each stroke to make sure it looks the way you want.

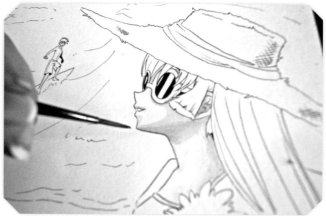

11 A key trick to manga illustration is to color the shaded areas, not the entire surface. Notice the white areas that remain after her face and neck have been painted.

12 To make some colors, you may have to mix two or three colors. To get the pink for her hair, I mixed two shades of red.

13 Do some crosshatching with your brushstrokes—it makes this hat look more realistic.

14 Dab some dots of darker brown to make it look like real sand.

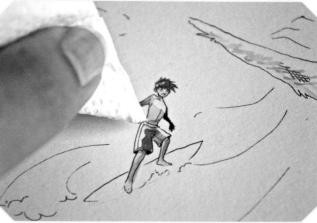

15 Keep a tissue around to dab parts with too much water.

Use White for Cool Effects!

Some watercolor sets have white paint in them. You can use it for cool effects.

16 Color the water with shades of blue. White paint is great for small 3-D effects like foam on a sea wave.

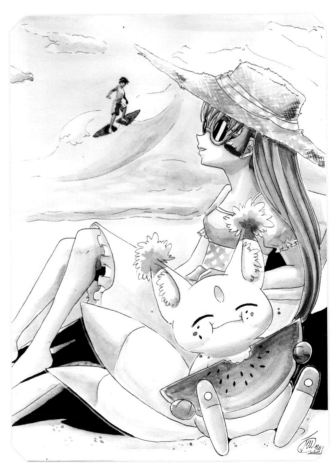

17 When you add white lines around an object or a character, it pops out.

You Try It!

Try replacing these characters with your own characters and draw them relaxing on the beach or having a picnic.

18 And there you go! A simple illustration of our mascots that anyone can draw.

VISIT **IMPACT-BOOKS.COM/MANGA-CRASH-COURSE** FOR BONUS CONTENT.

117

Draw a Simple Manga Page

Manga pages usually have up to six large pictures, and those pictures mostly have zoomed in faces to show the emotions in them. Very few manga pages have fully drawn backgrounds and bodies. These manga pages are drawn on an A4 (letter) or larger sheet of paper, and when it is scanned and shrunk, any mistakes are invisible.

MATERIALS

black permanent marker

eraser

fine liners (3 widths) or ink and ink pen

paper (A4 size or larger)

pencil

ruler

screentone (optional)

1 Sketch stick figures and plan out the scenes and text. This will be a page about how our mascots met.

2 Add more details such as clothes and hair.

3 Never avoid drawing emotions; It's one of the most important parts of drawing manga.

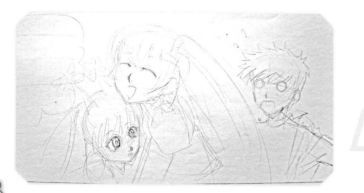

4 Try not to draw the text balloons too close to the paper's edge.
When drawing on big paper, make big text balloons. When you add the text, the letters should be ½" (1cm) tall.

5 After your sketch is complete and to your liking, ink over the main pencil lines. Use at least 3 line thicknesses: thickest for the borders, medium thickness for the text balloons, thinnest for characters and details.

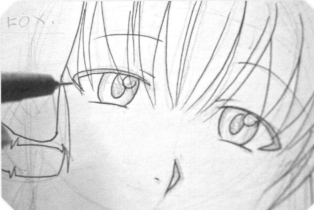

6 Keep the lines you like the most by drawing them in ink.

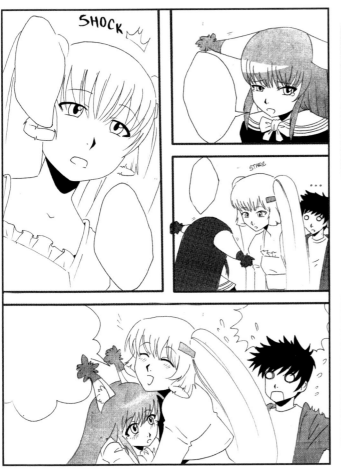

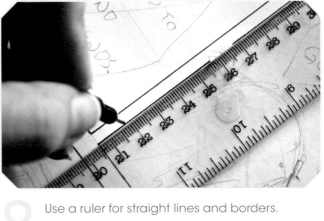

8 Use a ruler for straight lines and borders.

7 Manga borders have no limits. They can be open, closed, tilted, joined or far apart. Play with them, experiment and have fun. What's even more fun is when the characters break out of the borders!

9 After you've inked the characters and borders, erase the pencil lines. Be careful not to damage the paper.

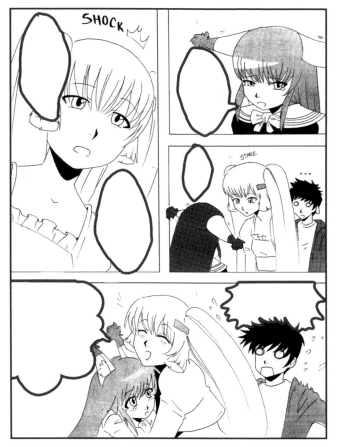

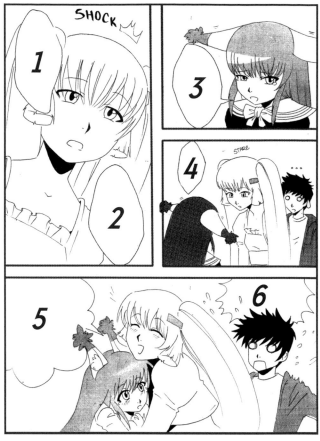

10 Text balloons are big open areas. You can shape them as narrow ovals to look like Japanese manga. Different emotions have different balloon shapes—bubbly for comfort, or sharp for yelling.

11 If you are from a country where books are read from left to right, you should make your manga flow in the same direction, from left to right, top to bottom.

12 Use a piece of screentone or simple crosshatching to get gray areas for shading the character's hair or clothes.

13 By scratching the screentone in certain areas, you can make the shiny or highlighted parts of hair, or any other darker area.

14 Add lines around the text balloons to show sound effects on the pictures.

15 Fill in black areas using a permanent marker to make the characters jump out from the page.

16 Write down all the smallest sound effects like: "shock," "rustle," "shaking," "plop," etc.
Try to make an equal amount of space for text balloons, black areas, gray areas and white areas to balance the composition.

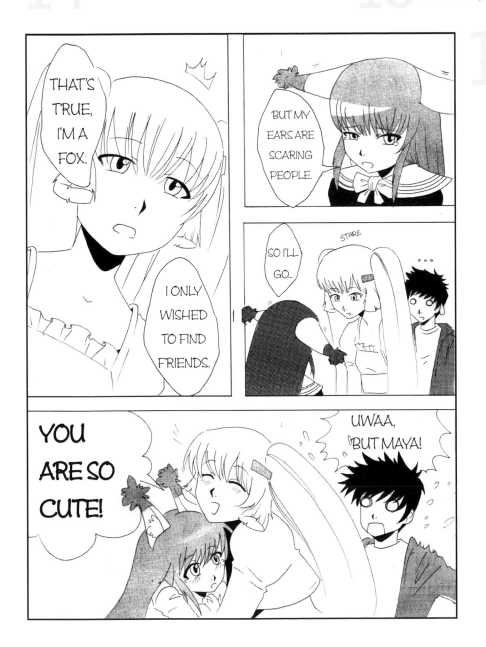

VISIT IMPACT-BOOKS.COM/MANGA-CRASH-COURSE FOR BONUS CONTENT.

121

YOU CAN BE A MANGA ILLUSTRATOR

Manga is beautiful and fun to create whether you like making full comic books or just drawing and coloring pretty characters. As an illustrator you will never get bored, and you will have an entire world of colors and themes to play with. Experiment every day with different tools and techniques, and remember that the most important tool you have is your imagination!

CONCLUSION

This is where our manga journey ends for now, and where your own stories begin! I will leave the final words to our crazy cast of characters:

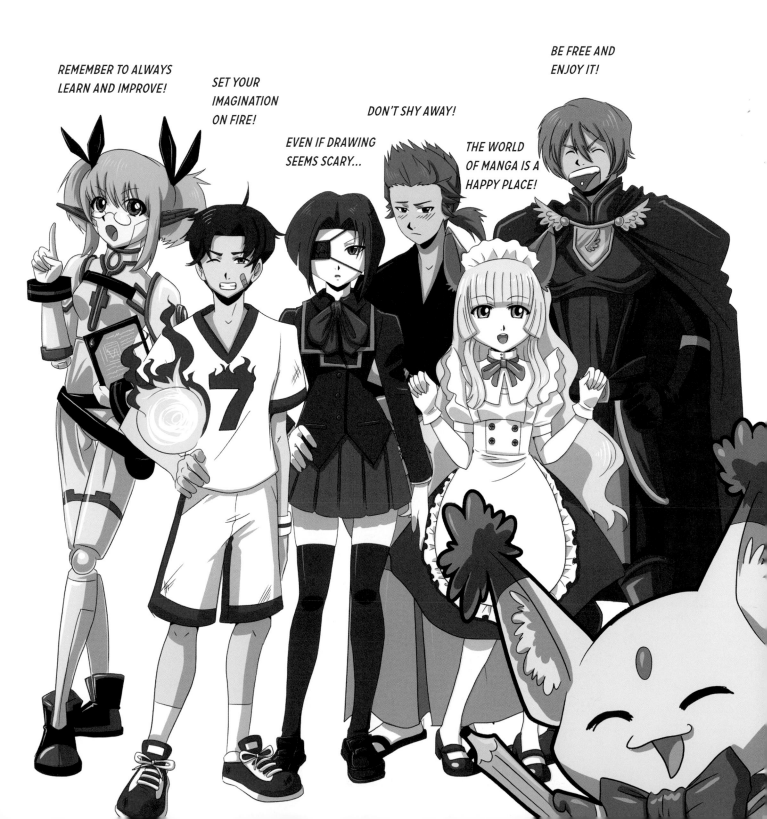

REMEMBER TO ALWAYS LEARN AND IMPROVE!

SET YOUR IMAGINATION ON FIRE!

EVEN IF DRAWING SEEMS SCARY...

DON'T SHY AWAY!

THE WORLD OF MANGA IS A HAPPY PLACE!

BE FREE AND ENJOY IT!

ACKNOWLEDGMENTS

I wish to thank my dear assistant, Marina, for working with me on this book. I also wish to thank my colleagues, Bojan and Isidora, and my friends Anya, Maria, Kvarta, Laura, Vedrana, Ivana and Dara for being a constant source of support. Also, thanks to my parents, family, friends and my dear students for believing in me. And to all of you reading and enjoying this book and my work, thank you.

Dedication

I dedicate this book to my dear Elyce, who went out of her way to support and trust me, opening an entire world I never thought I would see.

ABOUT THE AUTHOR

Mina Petrović, better known as "Mistiqarts," is a manga illustrator and teacher born in 1987 in Belgrade, Serbia. In 2009, she graduated with a degree in fashion design and won first place in a manga competition sponsored by the Japanese embassy. Since then she has created one of the top manga workshops outside Japan as a part of the "Sakurabana" fan society. Mina also works as an anime convention organizer and a lecturer on Japanese pop culture in association with the Japanese embassy in Serbia. A frequent YouTube contributor and online mentor for aspiring manga artists, Mina can be found online in the following places:

youtube.com/user/mistiqarts
mistiqarts.deviantart.com

PHOTO BY IVANA ALEKSIĆ

VISIT **IMPACT-BOOKS.COM/MANGA-CRASH-COURSE** FOR BONUS CONTENT.

125

INDEX

MANGA CRASH COURSE Copyright © 2015 by Mina Petrović. Manufactured in the United States of America. All rights reserved. No part of this book may be reproduced in any form or by any electronic or mechanical means including information storage and retrieval systems without permission in writing from the publisher, except by a reviewer who may quote brief passages in a review. Published by IMPACT Books, an imprint of F+W, A Content + eCommerce Company, 10151 Carver Road, Suite 200, Blue Ash, Ohio, 45242. (800) 289-0963. First Edition.

a content + ecommerce company

Other fine **IMPACT** Books are available from your favorite bookstore, art supply store or online supplier. Visit our website at fwcommunity.com.

21 20 19 18 17 9 8 7 6 5

DISTRIBUTED IN CANADA BY FRASER DIRECT
100 Armstrong Avenue
Georgetown, ON, Canada L7G 5S4
Tel: (905) 877-4411

**DISTRIBUTED IN THE U.K. AND EUROPE
BY F&W MEDIA INTERNATIONAL, LTD**
Brunel House, Forde Close, Newton Abbot, TQ12 4PU, UK
Tel: (+44) 1626 323200, Fax: (+44) 1626 323319
Email: enquiries@fwmedia.com

DISTRIBUTED IN AUSTRALIA BY CAPRICORN LINK
P.O. Box 704, S. Windsor NSW, 2756 Australia
Tel: (02) 4560-1600; Fax: (02) 4577 5288
Email: books@capricornlink.com.au

ISBN 13: 978-1-4403-3838-0

Adobe® product screenshot(s) reprinted with permission from Adobe Systems Incorporated. Adobe® and Adobe® Photoshop® are either registered trademarks or trademarks of Adobe Systems Incorporated in the United States and/or other countries.

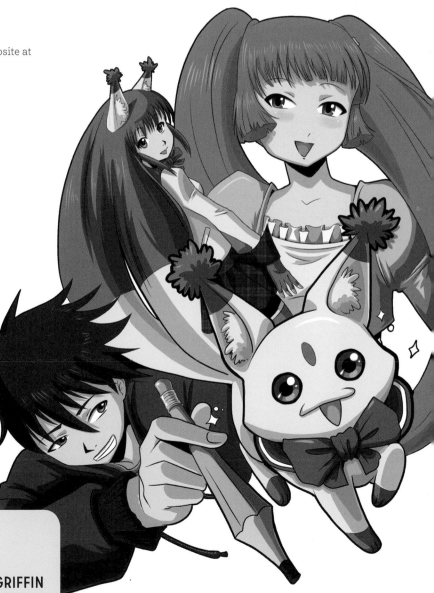

METRIC CONVERSION CHART		
TO CONVERT	TO	MULTIPLY BY
Inches	Centimeters	2.54
Centimeters	Inches	0.4
Feet	Centimeters	30.5
Centimeters	Feet	0.03
Yards	Meters	0.9
Meters	Yards	1.1

Edited by: **AMY JONES**
Designed by: **HANNAH BAILEY**
Production coordinated by: **MARK GRIFFIN**

IDEAS. INSTRUCTION. INSPIRATION.

Find FREE bonus demonstrations at
impact-books.com/manga-crash-course.

*Check out these **IMPACT** titles at impact-books.com!*

These and other fine ***IMPACT***
products are available at your
local art & craft retailer, bookstore
or online supplier. Visit our
website at **northlightshop.com.**

Follow ***IMPACT*** for the latest news,
free wallpapers, free demos and
chances to win **FREE BOOKS!**

Follow us! **@IMPACTBOOKS**

IMPACT-BOOKS.COM

- ▶ Connect with your favorite artists
- ▶ Get the latest in comic, fantasy and sci-fi
 art instruction, tips and techniques
- ▶ Be the first to get special deals on the
 products you need to improve your art